Print Collecting

BRYAN ALLEN

Print Collecting

FREDERICK MULLER

First published in Great Britain 1970
by Frederick Muller Ltd., Fleet Street, London, E.C.4

Copyright © 1970 Bryan Allen

Printed in Great Britain
by Ebenezer Baylis and Son, Ltd.
The Trinity Press, Worcester, and London
and bound by G. and J. Kitcat Ltd.
SBN: 584 10225 9

Contents

CONTENTS

Illustrations

7

Author's Note

This book has but one aim, to afford help to the ever increasing number of people who wish to make a collection of fine prints. Most of us have quite modest financial resources and not a great deal of time on our hands. I have tried to bear both these points in mind and have also cut down the use of technical terms to a minimum.

I hope it will help pilot its readers through a tricky subject, to a degree both of useful knowledge and aesthetic awareness. It is essential to enjoy collecting prints, and if I have been able to rub off a little of my own enthusiasm, I shall be content.

Acknowledgments

The following print sellers have been kind enough to allow the reproduction of works in their possession: Arthur Ackerman & Son Ltd., P. & D. Colnaghi & Co. Ltd., Folio Fine Art Ltd., Christopher Mendez, The Parker Gallery, Sanders of Oxford, Spink & Son, Ltd., Weinreb and Douwma Ltd. and the William Weston Gallery,

The British Museum, the Museum of British Transport, S.P.A. D.E.M., Paris, the Syndics of the Fitzwilliam Museum, Cambridge, and the County Borough of Reading Museum and Art Gallery, have granted permission to include photographs of prints in their collection. The London Fine Art Auctioneers, Sotheby & Co., have been most helpful in providing photographs of prints and four plates in this volume are included thanks to their assistance.

The section on "glass" pictures is based on an article in *Octagon*, published by Spink & Son Ltd., and I am indebted to two books of special value for the writer of a volume on print-collecting: the sixth edition of *Engravings and their Value*, by J. Herbert Slater, revised by F. W. Maxwell Barbour in 1925 for the *Bazaar Exchange and Mart* and, unhappily, long out of print, and Arthur Hayden's delightful and knowledgeable *Chats on Old Prints*, published in 1906 by T. Fisher Unwin. It was brought up to date by Cyril Bunt in 1957 for Ernest Benn Ltd., and is still an invaluable guide. Both books have been constantly at my side, and I have drawn on their expertise when in difficulty ever since beginning my own collection of prints.

1

What is a Print?

After a period out of favour, prints are popular once again. Most people like to look at them. Some are amusing, satirical, or even frankly scurrilous, representing a contemporary onlooker's opinion of a long-forgotten political manoeuvre. Others reproduce for the masses a well known painting, be it landscape, portrait, or vase of flowers. Many of the world's finest prints are in austere black and white, while others may have been coloured by hand. More modern techniques permit colour printing.

There is much excitement and many dangers for the beginner—forgeries, fakes, photo-mechanical reproductions, repaired or "restored" prints will do for a start. The amateur collector needs to know something of print-making techniques as well as possessing the ability to recognize subject matter that appeals to him.

Later on I shall outline the main technical processes and speak of the principal categories into which prints can be divided. Some technicalities are inevitable but the non-scientific reader can take comfort in the assertion that an eye for quality is the main requirement for the successful collector of prints. This comes only from familiarity with well-authenticated prints that can be found in the cabinets and folios of our museums and art galleries, and especially in the Print Rooms of the British and Victoria & Albert Museums.

Any impression made in ink by a hard block or plate upon paper can be called a print, and the block may be of wood, metal or stone. Many artists have made their own prints and these are *original* prints because they were both conceived and executed by the same artist. Modern artists like Picasso and Chagall produce their own "graphic work" and

obviously take pleasure in so doing. "Graphic art" is the term given to the art form produced by printing methods, but old prints by little-known artists abound and the beginner might do well to consider these before tackling rarer and more expensive prints.

Sometimes a print is referred to as an engraving. For most purposes, apart from technicalities, this is true. A print is the impression produced by an engraved block or plate, so that the term "engraving" is more applicable to the medium than to the impression itself.

Some artists like Morland and Bigg in eighteenth-century England kept numerous engravers in work and, at the same time, ensured a wide popularity for their paintings. George Morland, a ne'er-do-well drunkard, possessed a genius for depicting delightful scenes of rural England that were popularized by the mezzotints of his brother-in-law, William Ward. Such prints are technically "reproductive" prints in that the printmaker has copied another artist's design. They are described as being "by Ward after Morland" and sometimes can be of finer quality than the original painting.

Often the small printed words under a print can be informative to the collector. A magnifying glass may be needed so that he can interpret the lettering and discover whether the artist himself executed his own print. The words "Original Engraving" means that the man who engraved the plate also drew the design. Sometimes Latin words or abbreviations are used. On the left may be the artists' name with *"pinx"* or *"pinxit"*, meaning "he painted it", or *"del"* or *"delt"*, meaning "he drew it". On the right is the engraver's name and the abbreviation *"sculp"* or *"sculpsit"*—"he engraved it"; *"fec"* or *"fecit"*—"he did it", are also met, while the artist who was his own engraver would put his name and *"del et sculp"*.

Other Latin terms include *"lith"*, indicating that the artist drew the picture on the stone for the lithographic process, and *"imp"*, meaning that the artist printed the plate as well. James Whistler was a notable example of this "do-it-yourself" type of artist.

Prints that may confuse the tyro collector are those produced by photo-mechanical processes. These may have been issued without any

attempt to deceive and many, in fact, were given away by art magazines at the beginning of this century. It's not unknown for them to be foisted on the unwary as originals. Many modern prints are reproduced by photographic methods and even if they are signed by the artist it does not make them original prints. All that the collector has acquired is an artist's autograph, assuming it's genuine.

Certain categories of modern prints are increasing in popularity so that prices rise and publishers flourish. Modern technical processes enable a publisher to run off copies almost indefinitely, yet despite the demand some publishers take care to produce only limited editions. Rich men like to feel they are enjoying a restricted pleasure denied to other collectors. Having paid £100 for a Braque lithograph, a connoisseur is comforted to think that there are, say, only 99 other copies in existence and that his copy is numbered and signed by the artist.

Prints, then, or certain categories of them, can mean big money, and, indeed, between 1966 and 1968 good quality print prices appreciated by 70–80%. This doesn't mean that anyone with a print could expect to get that much more for it, but, rather, that the best original prints effected this rise over all.

Some figures underline the trend. In March, 1966, a fine impression of Rembrandt's etching *Christ Healing the Sick*, sometimes called "the hundred guilder print" because it was sold for one hundred guilders in the artist's lifetime, realized £26,000 at auction, compared with £1,750 in 1930. Sixteen engravings of *The Passion* by Albrecht Dürer, which might have cost £25 in 1935, fetched £1,800.

And yet the paradox is that prints as a whole represent a genuinely democratic art form enabling people to enjoy a work of art of which they would otherwise be deprived. Only a minority of museums and business tycoons can afford to buy an oil painting by Goya, yet his incomparable etchings and aquatints can be purchased for as little as £15. Such little masterpieces attract no attention from those who make a fetish of colour, although, of course, the purist will look with disfavour on a colour print anyhow. In the old days, colour could be

applied only when the original work on the plate was worn out and when a satisfactory impression was no longer possible.

With such warnings sounding in the ears, what are the qualities desirable in a print? Firstly, it should be a fine impression—bright and clear. If the plate has no signs of wear, there will be an immediately obvious sharpness of line. Different types of print provide different effects of richness and brilliance; thus in a mezzotint, a quality of fine "bloom" is commonly sought. Always, though, are signs of wear and tiredness to be avoided and these are usually indicated by an absence of clarity in those lines on the print obviously intended to be distinct. Sometimes wear is revealed by a dullness of tone where the subject is clearly not intended to be monotonous or even.

To assess the condition of a print, the prospective buyer should take it up in both hands and notice, firstly, whether the paper feels suspiciously thick. If it has been "backed" it may have been done to hide some defect. There is, indeed, a method of preserving prints known as "laying down", whereby the print is pasted on to cardboard or thin canvas so that the resultant thick foundation will prevent any fraying. Where a torn or ragged print needs binding together this habit is perhaps defensible, but not merely does it suggest that there might be something to hide, it also means that any collector's marks on the back are covered up, thus obscuring evidence of the print's quality.

Good light is desirable for the examination of an old print and a magnifying glass will reveal if it has been repaired or otherwise "improved". If the print is framed this can be difficult as dealers are naturally reluctant to allow every Tom, Dick and Harry to take a print out of its frame. This suggests that, at least in the initial stages of a collection, a print-collector would be well advised to go to a reputable dealer and leave the risks of the auction sales-room until later. All the finest collections in the visual arts have been created as the result of a collaboration between dealer and client, and the happiest collector is one who has explained the facts surrounding his proposed collection to the dealer of his choice and allowed himself to be swayed by the

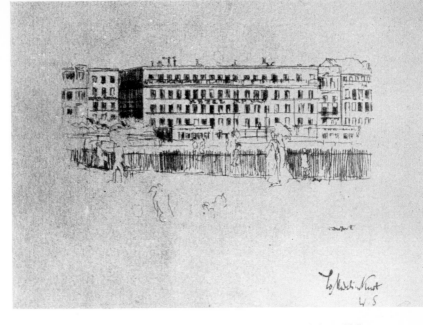

Above, an etching by Walter Sickert, the Hôtel Royal, Dieppe; *below*, "The Temptation of St. Anthony", an etching by Jan de Cock after Hieronymus Bosch

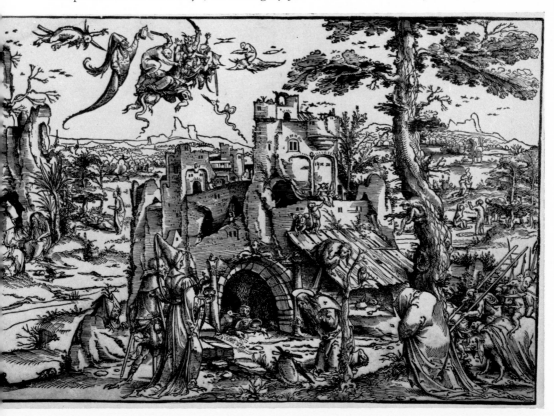

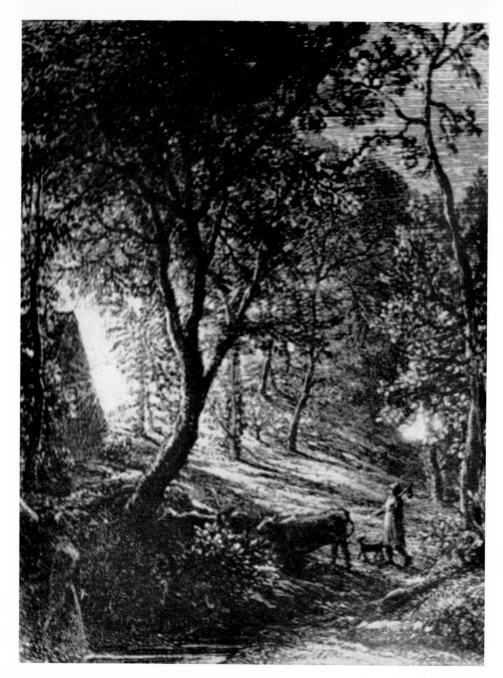

"The Herdsman's Cottage", etching by Samuel Palmer

latter's opinion. Clearly no dealer of standing ever yet built up his business by taking advantage of the inexperience of his customers.

Obviously a beginner will need to attain a practical knowledge of the various styles of engraving; for example, he must be able to decide whether a particular print is a lithograph, aquatint or mezzotint, and, in the next chapter, the reader is introduced to the characteristics of each type of print.

At this stage the beginner should not worry about "proofs" and "states" but leave them to those collectors rich enough to pay for them. A "proof" means that the print-maker took an impression from his plate to see how his work was developing. If he decided to alter the plate the print taken from it may be listed as a different "state"— 1st, 2nd or 3rd, for instance.

Likewise, the beginner should avoid the fashionable areas of print-collecting for it is here that he will pay the highest prices and, also, it is the field of operation by the forger. Fifty years ago, the weak and fancy-coloured subjects of Bartolozzi were all the rage; later Morland had his turn, while nowadays the old masters are justifiably back in vogue. Good examples of the stipple work of Bartolozzi, Cipriani and their imitators are now reasonably priced and it is for the clever collector to take advantage of changing fashions and trends. As an example, P. W. Tomkin's stipple engraving *The English Fireside* sold for £20 in 1906; today it is rarely seen and probably would not even be separately catalogued in the sales-room. Specimens of the portrait work of Valentine Green, perhaps the finest engraver working in mezzotint that this country has produced, were priced in hundreds of pounds sixty years ago. Now they cost no more than as many shillings.

The moral is that the poor amateur should bend fashion to his will. Quality is always better than quantity regardless of the canons of taste. The wisest collector limits himself to a few masters at a time and studies carefully their works with the help of authoritative works of reference.

2

The Different Types of Print

One way to classify prints is to separate them into categories according to the different technical processes used. Some of these processes are more important than others. The collector need not get too involved in technical terms but a broad outline of the various methods used will be invaluable to him.

ETCHINGS

The basic facts which govern etching are that if a piece of copper is submerged in acid it is corroded, whereas wax substances remain unaffected. To produce an etching, the surface of a metal plate, usually copper, is polished and a layer of wax varnish is applied to it. By drawing on the plate with a special needle, the copper is exposed, and this is eaten away when the plate is placed in a bath of diluted nitric acid. The artist using the needle has great freedom of movement, just as much as in a drawing, although, of course, designs are drawn in reverse. They will be printed on paper where the copper plate will leave a mark—the plate mark. Objects which face right on the plate will face left in the finished print.

Etching is thus an incision into metal—the reverse of a woodcut which stands out in relief. It is popular among artists because it is relatively easy to draw fancy lines of all shapes on a metal plate; and their depth and quality can be varied by using the process known as "stopping out". If the etcher does not want a particular part of the copper plate to be eaten by the acid then he "stops it out" with varnish which resists the acid. Lines that he wishes to appear fine or faint he

will "stop out" quickly, while others that are to appear black will be left for the acid to work on longer. The action of the acid on the metal is called "biting in".

The earliest known etching was the work of a Swiss, Urs Graf, in 1513. Variations of this process exist: *Soft-ground etchings* are created by using a technique in which tallow is added to the etching "ground". The design is not traced with a needle but with a pencil instead, on a sheet of paper stretched over the "ground" on the plate. The "ground" sticks to the parts traced so that when the paper is lifted off an impression is left and the plate can then be "bitten" by the acid in the usual way. This method was used at the beginning of the nineteenth century to reproduce crayon drawings. Thus Gainsborough chose as subjects in this medium pastoral scenes like a shepherd reading the inscription on a gravestone by a rural church, or a woodland glade with two figures standing in front of a cottage. Often such etchings would be trimmed close to the plate and mounted as drawings.

Dry-point etchings are lines scratched into the surface of a metal plate with an etching needle and without the use of any acid. A metal shaving or furrow is thereby raised immediately beside the line. This is known as a "burr" and it is this little ridge of copper which gives the rich, velvety quality to dry-point etchings when they are printed.

Dry-point can be a separate process or it may be used in conjunction with etching when it gives strength and depth as needed.

It is hardly surprising to find that many painters have also been etchers, for etching, unlike other engraving processes, is speedy and sensitive. The collector will find considerable choice both in subject matter and price ranging from early Old Masters like Dürer, Lucas van Leyden and Claude right up to Whistler and the French Impressionists.

Rembrandt was probably the first great master to use etching on a large scale and many critics consider him the greatest etcher of all time. An enormous quantity of etchings is attributed to him, including landscapes, portraits, religious subjects and nudes. Most of them, however,

are sold at prices beyond the range of the modest collector. For instance, a clean impression of *Christ and the Woman of Samaria at the Well* from an edition as late as 1780, over a century after Rembrandt's death, would sell for approximately £150 today. His work is always in demand; as recently as fifteen years ago a splendid Swedish bible was produced with Rembrandt reproduction by way of illustrations.

There are a vast number of painters who were etchers and it is only possible to suggest here some of the more important or interesting.

Early Masters

Wenzel Hollar—published over 2,500 etchings on a wide variety of subjects including topographical scenes, portraits and figure studies. Worked for many years in this country so that there are numbers of topographical prints in his rather stiff style, like *The Hollow Oak of Hampstead*. Unusually diligent and honest, he is stated to have provided illustrations for booksellers at the rate of 4d. an hour, calculated by means of his hour glass. He prevented the sand from falling through when talking to his employer on his own business. Jacques Callot—military scenes, wartime studies.

Dutch Seventeenth-century School

Van Ostade, Potter, Ruisdael—genre, landscapes and pastoral scenes. Potter is the "cow" man.

Eighteenth-century Italy

Canaletto—photographically accurate scenes of Venice and London. Tiepolo—*Scherzi di Fantasia*. (Whimsical Sketches). Piranesi—prison scenes, Roman views and buildings. Ghezzi—satire and religious subjects.

Nineteenth-century France

Charles Méryon—views of pre-Haussmann Paris; he worked with a pocket mirror, drawing the reflection of his subject. Delacroix—North African scenes.

Millet—landscapes, peasant studies.
Corot—less than twenty etchings, some of Italian scenes.
Camille Pissarro—landscapes and figure studies.
Degas⎫
Manet⎭figure studies.

The English Caricaturists
Gillray
Rowlandson
Bunbury
The Cruikshank family

The English Romantics
William Blake—an extraordinary visionary who devised an unusual etching technique of his own. Subsequently hand coloured, these prints are beyond the reach of modest collectors; most are in museums anyhow. For an idea of what they are like, see *William Blake, Poet, Printer, Prophet*, by Geoffrey Grigson, Oxford University Press, 1965.
Samuel Palmer—stands in the Blake tradition; executed only a few small etchings of a pastoral nature which are very sought after. Specimen titles—*The Herdsman's Cottage*, *The Bellman* and *The Weary Ploughman*.

Less fashionable French
Jean Louis Forain—came to etching late in early 1900s and chose subjects from the Law Courts, law-life and religion: *La Sortie de l'Audience, Maison Close, Avant le repas à Emmaus.*
Maxime Lalanne—prolific etcher of French scenes: *Fire in Bordeaux Harbour, View of Trouville.*
Alphonse Legros—settled in England and had a considerable influence: *Sir Edward Poynter, Lord Leighton, Paysage Breton.*

Bargain Basement

Robert Austen—living; specimen titles: *Spring-time at Fulham*, *Palm Sunday*.

Sir Frank Brangwyn—began life by making tapestry designs for William Morris. The most representative collection of his works is at the William Morris Gallery, Walthamstow, London E.17. (The Brangwyn Bequest). There is also the Brangwyn Museum in his birthplace, Bruges, Belgium.

Edward W. Cooke, R.A.—splendid sea and river scenes: *London Bridge being built*, 1831, *H.M.S. Victory*.

Sir Herbert Dicksee—*My Lady Sleeps, The Death of Gordon*.

Sir Alfred East, R.A.—better known for oils and water colour landscapes. Etched a number of large scenes including *A Spanish Garden* and *A Glade in the Cotswolds*. The Art Gallery in his native town of Kettering contains good examples.

Edwin Edwards—English scenes: *Hampton Court, Babbacombe Bay*.

Frederick L. Griggs, R.A.—fine architectural draughtsman. Mediaeval and pastoral subjects: *St. Botolph's, Boston, Old Houses at Hitchin*.

Martin Hardie, R.A.—*Ajaccio, A Wood at Chartres*.

Dame Laura Knight—*An English hillside*.

Possible investments for the future

Sir Muirhead Bone—architectural, "draughtsman" etchings.

Sir David Cameron R.A.—numerous rather stark plates: *Ben Lomond, Gloucester, Souvenir d'Amsterdam*.

For a collector interested in examples of the best in the modern English tradition, the works of Augustus John and Walter Sickert must rank high in his list. John was a splendid portraitist and good examples of his work include: *Wyndham Lewis, Epstein*, and *The Charwoman*.

Sickert is associated with representations of Bath and Dieppe. The *Hôtel Royal* at Dieppe seems to have been a particular favourite of his

and there is an oil painting of the same subject in the Ferens Art Gallery at Hull. The etching possesses an enhanced value in the shape of the inscription to Walter Knox, one of the artist's friends, and the initials of the artist, "W. S.". Sickert also executed fine prints of the theatre and stage, often in the Old Bedford Theatre. There are the figure studies and nudes associated with his *Mornington Crescent* period and, just to show his versatility, the superb still-life of *Mushrooms* published by the Carfax Press.

Sometimes an opportunity occurs for the enthusiast to acquire etchings by a contemporary master—one who has been admitted to the select group of acknowledged major artists in his lifetime. Such a man is Marc Chagall. Music lovers can admire his painted ceiling at the Paris Opera and the shrewd collector can find smaller but equally fine examples of his work, e.g.: *Rebecca at the Well* and *David's Victory over Goliath*, from his "Bible" scenes, or; *The Fox and the Stag*, and *The Partridge and the Woodman* from his illustrations for the Fables of La Fontaine.

Most connoisseurs have their own particular favourite graphic artist. Almost certainly Goya will be the choice of many. Two well-known series are: *Los Desastres de la Guerra*, eighty plates of bitter reaction to the brutality of Napoleon's invasion of Spain, and *Los Caprichos*, which provides the same number of impressions but this time devoted to varying aspects of human behaviour. *Aquellos Polbos* illustrates number 23 of this series. The subject is a court scene with the judge reading the depositions and the prisoner resigned in his long pointed cap. The quotation of the title reads, "From this dust comes this mud". Prisoner and judge, according to Goya, are equally guilty; the social system is responsible, and the rapacious looks on the faces of the lawyers, jury and hangers-on in the court-room, underline Goya's contempt for the "status quo".

Even in a technical sense Goya was a genius, not content with adding dry-point and engraving to etching as Rembrandt had done, but also using mezzotint and aquatint as well. Little wonder that even late reprints of his works are sought after and that the publishers touched

up his plates showing signs of wear! He also completed thirty-three etchings, *Scenes in the Bull Ring*, and *Los Proverbios*—eighteen plates.

Collectors interested in soft-ground etchings may come across the works in this medium by the Norwich School artists, Crome and Cotman. Of the two, Crome's etchings appeal more to twentieth-century taste. Few artists have depicted trees so well and he seemed never to be able to resist drawing them.

Cotman's soft-ground etchings are full of attention to architectural detail. A good example is his *Architectural Antiquities of Normandy* of 1822, odd plates from which may be encountered in print-sellers' folios.

Among modern artists there is a very effective portrait by Dame Laura Knight, *Ethel*.

As for dry-points, fine examples can be found among the works of modern, less well known artists. Stephen Gooder, C. R. W. Nevinson Muirhead Bone, William Strang and D. Y. Cameron would make good starters. *A Spanish Good Friday* by Muirhead Bone is the artist's most famous dry-point and a superb twentieth-century print.

WOOD ENGRAVINGS

The oldest method of reproducing a design, this was practised in Britain before the fifteenth century. The artist selects a piece of wood, box-wood is often considered best, and cuts away all those portions of the design he does not propose to print in black. When his cutting away is completed, his drawing stands in relief to the rest of the block, which is cut down to a depth of about one-eighth of an inch. The surface of the wooden block is then inked, paper placed over it and the whole is put through a press. Wood engraving is thus exactly opposite to engraving on metal although it is possible also to cut into the wood with an engraving tool or burin; this is a sharp-pointed instrument with a wooden handle which makes lines in the metal by being pushed away from the engraver.

Wood engraving held its own until late in the nineteenth century largely because all forms of engraving on metal are costly. Dürer and

24

"St. George and the Dragon", woodcut
by Albrecht Dürer (*British Museum*)

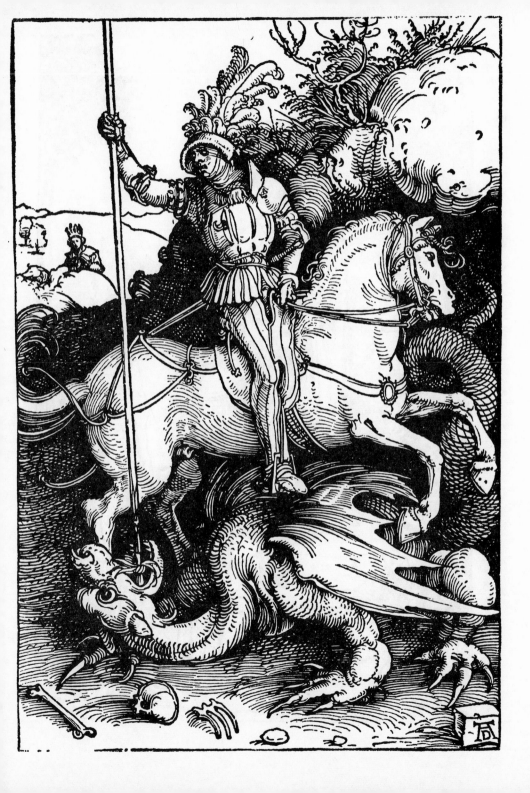

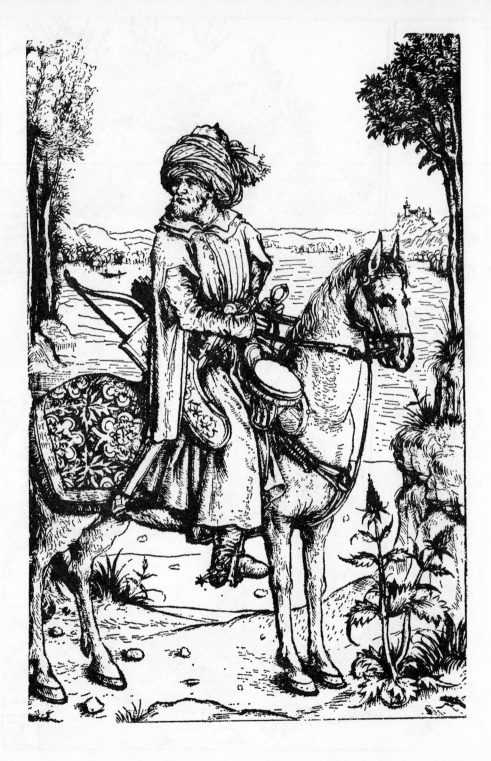

Holbein were among the early masters to use the medium, although there is some doubt whether they ever cut their own blocks or even drew on wood. More likely, professional engravers worked, even then, after the artist's designs. The kind of early subject that appealed to fifteenth- and sixteenth-century taste is the well-known *Dance of Death* scene, drawn by Holbein but existing in many pirated versions. The subject existed on the walls of many churches and perhaps the most vigorous treatment of the theme is to be found at the Abbey of La Chaise-Dieu in Central France.

Many of the earliest woodcuts are limited in scope and coarsely if not crudely reproduced, although distinctive improvement was noticeable in the style of the cutters who worked after Lucas Cranach, Goltzius and Lucas van Leyden. Cranach and Dürer were attracted by mystical or biblical themes that can seem overpowering to some sophisticated twentieth century tastes. Prints with titles like *The Seven-Headed Beast, St. George and the Dragon* or *The Beheading of St. John the Baptist* indicate their vigour. Where engravers on wood turned to contemporary persons the infidel Ottoman conquerors occupying so much of south-eastern Europe might provide a suitable subject such as *A Mounted Turk*, until recently given no firm attribution by the British Museum.

In the seventeenth century wood engraving was in decline and used mainly for rough illustrations to political broadsheets or early newspapers, like *London's Intelligencer*, published in 1643. It contained woodcuts of Charles I and Fairfax.

This state of affairs continued into the late eighteenth century when Thomas Bewick of Newcastle-on-Tyne gave a new impetus to this art form. Bewick was a countryman by birth who seemed to understand the limitations of working in wood. Among his best known works the collector will find *British Quadrupeds* and *History of British Birds*. Most of his engravings are quite small, some only two by three inches.

Wood engravings came back into fashion in Europe in the 1830s as illustrations for books and magazines. Daumier produced thousands for humorous and satirical magazines such as *Le Charivari* and *Le*

"A Mounted Turk", woodcut by an unknown artist, possibly the Master of the Hausbuch (*British Museum*)

Monde Illustré, and in Germany, too, Caspar Friedrich and Alfred Rethel helped popularize the revival. In Victorian England, the foundation of the *Illustrated London News* in 1842 gave a fresh stimulus to the wood engravers, of whom the most celebrated were the Dalziel brothers. They reproduced the drawings of fashionable artists like Millais, Rossetti, John Gilbert, Frederic Leighton and Arthur Hughes. The collector can find examples in Victorian magazines like *Once a Week*, *Good Works*, *Cornhill Magazine* and *Sunday Magazine*, although these publications are not so easy to find nowadays as they were a few years ago.

The very popularity of wood engraving brought about its downfall; large editions of books and magazines were called for by the Victorian public and the wood blocks just could not withstand the ravages of the printing process. These mid-Victorian wood engravings are not particularly sought out even today and the beginner may well find that this is a profitable field for him.

In the case of illustrated books with fine bindings it's a different tale. For some time, shrewd collectors have sought these out and prices are high and still rising. In this case, he will do well to look for the works of the lesser known artists—Luke Fildes, Hubert Herkomer, George John Pinwell, Frederick Sandys and Frederick Walker are names that come to mind.

One reason for this rise in public esteem is that wood engraving received a new impetus at the careful hands of William Morris and his Kelmscott Press. Morris's respect for fine craftsmanship would have delighted the most exigent master of the Middle Ages. A similar high standard was established by Charles Ricketts and Charles Shannon with their Vale Press and, especially, when they used the illustrations of Lucien Pissarro. Unfortunately, the output of these presses is beyond all but the richest collectors. Towards the end of the nineteenth-century in France, Aristide Maillol, the sculptor-illustrator, worked in wood, sometimes only with a scoop as in *La Vague*, 1895. Maillol's nudes are more usually associated with lithographs like his illustrations for Ovid's *Art d'Aimer*, but this fine woodcut shows

the enhanced technique of a modern master. Other more recent artists have also worked in wood, the mystic Eric Gill, Gwen Raverat and her quiet landscapes, while Paul Nash, even more than his brother John, caught a vision of cold bare trees and lonely figures in his *Landscape under Snow*. Prices are rising, however, and it is pleasant to record the appreciation at their real worth of Gordon Craig's stage designs or the posters of Sir William Nicholson and James Pryde—the Beggarstaff Brothers. Only the work of Sir Frank Brangwyn among the onetime

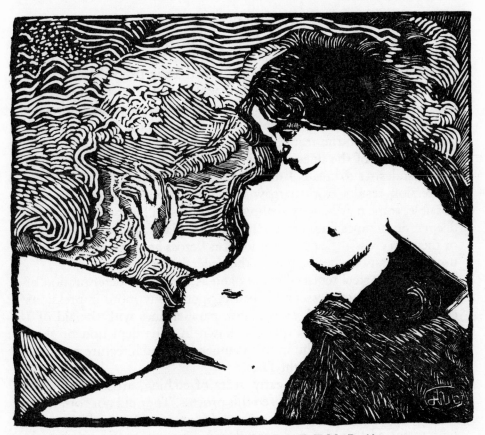

"La Vague", woodcut by Aristide Maillol (*S.P.A.D.E.M., Paris*)

"greats" seems to be selling slowly and this tendency must soon be reversed.

The more adventurous collector who backs his fancy can visit the annual exhibition of the Royal Society of Painter-Etchers at 26 Conduit Street, London W.1, where he can find modern, low-priced examples of this ancient craft.

LINE ENGRAVINGS

Line engraving developed from the goldsmith's art and is a process of considerable antiquity. Before 1820 a plate, generally of copper, was used and a design cut into it by a burin, or a graver as it was also called. As we've seen, it is used by being pushed away from the engraver, which makes free, spontaneous movement, as with the etching needle, impossible. This form of engraving is a laborious, painstaking process and years may have been spent by an engraver on one plate before he was satisfied with the result.

The nature of the lines incised varies according to the impression the artist desires to create. Broad lines make for coarseness while a fine impression results from narrow lines. Variations of depth are also possible, some may be very shallow and others will be proportionately deeper. Sometimes lines can be thick in one place and thin in another, or they can cross—the process known as "cross hatching". The skilful use of dots and dashes heightens the general effect.

After 1820, steel replaced copper and as the rate of deterioration of steel plates is much less rapid than copper, many more impressions could be "pulled". With steel plates, parallel lines with the aid of a ruler could be easily and quickly drawn in. The depiction of skies and seas was usually done in this manner while architecture could be effected by straight, upright lines.

Once again, as with the early years of etching, artists who were painters as well as engravers used this process. They did not copy their own canvasses but simply wrought a design on copper which could be transferred to paper and reproduced. The same early masters al-

ready listed as etchers worked with the burin—in Italy, Germany, Flanders and, ultimately, England. The golden age of line engraving flourished in France at the time of Louis XIV. Robert Nanteuil, Pierre Simon and the Drevet family, especially Pierre (1663–1738) and his son, Pierre Imbert (1657–1739), have bequeathed to us their celebrated portraits of the statesmen and courtiers of the time. Pierre Imbert Drevet produced a famous full-length study of Bishop Bossuet after the Court painter, Hyacinthe Rigaud. Equally fine is a religious study after Antoine Coypel—*Abraham's ambassador offering a gift to Rebecca*, the original of which is in the Louvre. The subject matter is clearly of interest to artists. Chagall chose it for one of his "Bible" illustrations.

If we associate the seventeeth century with portraits, perhaps we can find in landscape an awakening interest of the eighteenth century. Claude, Poussin and Vernet all found interpreters to popularize them in line. In due course, their world of classic landscape with ruined temples and flowing streams collapsed in ruins with the onset of the French Revolution, but it has been perpetuated in England by William Woollett who is perhaps his country's finest engraver in line. A good example of his technique is his *Cicero at his Villa*, after Richard Wilson.

Hogarth also worked in line and those collectors interested in the satire of manners will obviously be drawn to his work. Care, however, is needed in collecting his engravings; they have been so popular that many impressions were printed on old or damaged plates.

Line engravings are still very cheap and the sales-rooms tend to turn their backs on them unless their perpetuator bears a famous name. This is even more the case when we turn to the nineteenth century when line engraving entered its last phase. Steel plates might be engraved by several men working together, although even in this period of decline the occasional fine example can be met. Most collectors will be familiar with the topographical engravings of William Finden, like his *Ports and Harbours of Great Britain*, published in 1842. Edward Goodall, a self-taught engraver, was most successful in reproducing engravings after Gainsborough, and Robert Brandard

was among the best of the artists working after Turner's designs. Equally effective were J. T. Willmore and John Pye. Their small but delightful illustrations after Turner's drawings can be found in such volumes as Samuel Rogers' *Poems* and *Italy*. Willmore, and his younger brother Arthur, engraved numerous pleasant drawings of the English countryside by their Victorian contemporaries, including those by Myles Birket Foster.

MEZZOTINTS

This process represented an attempt to reproduce tones rather than lines. The copper plate is covered with a mass of tiny dents made with a special tool called a rocker. After a complicated scraping on a prepared ground, a pattern of light and dark shades can be established. First invented by Ludwig von Siegen, an officer in the service of the Landgrave of Hesse, in 1641, its development belongs essentially to the late eighteenth century and to England. Mezzotint is very suitable for reproducing oil paintings, and its soft, rich sheen proved admirable to popularize the works of Reynolds and Gainsborough. Later, mezzotints were produced after the genre paintings of Francis Wheatley and Joseph Wright of Derby. One of the medium's finest exponents was Richard Earlom whose treatment of Wheatley's *Going to Market* made the finished print almost more desirable than the original oil painting. Earlom's handling of the Fruit and Flower Pieces of van Huysum have always made these prints highly sought after.

Mezzotints are for browsers, as one might expect from an essentially eighteenth-century medium. Looking at the Royal Collection after dinner was a favourite occupation of Queen Victoria.

Among artists who worked in mezzotint the collector will find: Edward Bell and the Dawe Family—fine plates after George Morland. William Dickinson—portraits after Reynolds and Hoppner. William Barnard—really splendid colour plates, among them *The Country Butcher*—after Morland; *The Benevolent Milkmaid*—after Wheatley; *The Peasant's Integrity*—after Bigg. John Dean—portraits

...ogenes", a chiaroscuro woodcut ...Ugo da Carpi after Parmigianino; ...v, etching by William Ward of the ...st Bridge at Leicester, 1872, with ...church of St. Mary de Castro in the background

"The Hollow Elm of Hampstead", first state of a rare etching by
Wenzel Hollar

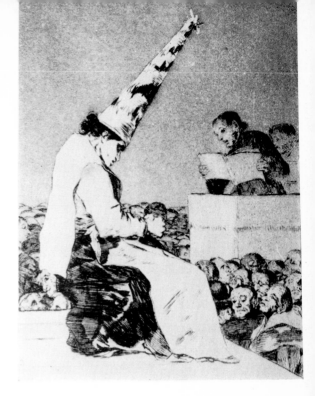

"Acquellos polbos", etching and aquatint by Goya; *below*, "A Singing Lesson in a Finishing School for Young Ladies", an early nineteenth-century line engraving by an unknown French artist

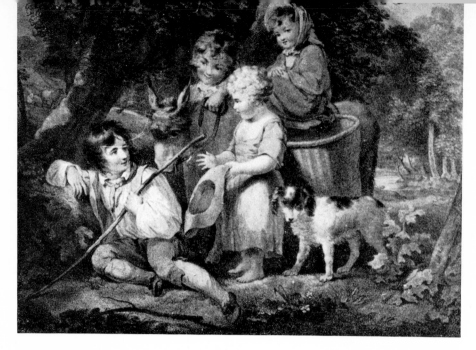

Above, "The Young Fortune Teller", a stipple engraving by Thomas Gaugain after Richard Westall; *below*, "The Soldier's Widow", a colour mezzotint by Robert Dunkarton after William Bigg

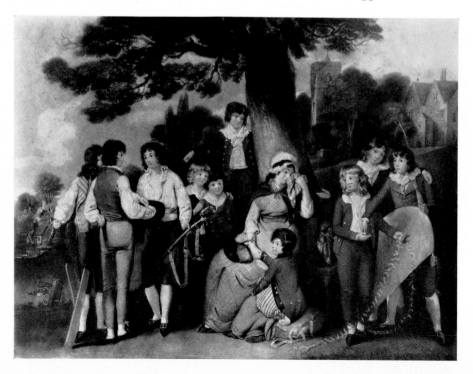

after Reynolds. Samuel Cousins—*Master Lambton*, after Lawrence; *La Surprise*, after Greuze. Robert Dunkarton—well-finished prints, after Bigg. Valentine Green—fine portraits. George Keating and Joseph Grozer—desirable impressions in colour after Morland. James McArdell—an Irishman; Reynolds declared that he had been "immortalized" by McArdell's mezzotints of his portraits. William Pether —gradations of light and shade; moonlight or candle-lit interiors. Samuel W. Reynolds and Charles Turner—the best of the post-1800 mezzotinters. John Raphael Smith and the Ward brothers, James & William—the best known mezzotint artists. Thomas Watson—beautiful portraits. Six of them after Lely, *The Windsor Beauties*, are especially highly regarded.

Although mezzotint is sometimes referred to as *"la manière anglaise"*, the medium was popular for a time in other countries, so that the collector should be prepared to meet other than English examples. Possibly the finest—and the most expensive—are the few mezzotints executed by Louis Philibert Debucourt, whose work in colours is always admirable. Whatever the country of origin, however, the appearance of most mezzotints is peaceful—a graceful and pleasing subject washed with skilfully blending tints, building up subtle gradations of light and shade which are a feature of the medium. There are a few modern British artists who exhibit mezzotints. *Lunar One*, by Leonard Marchant, is a good example.

STIPPLE ENGRAVINGS

This process is a variation of the technique used by etchers. A metal plate, usually copper, is covered with a wax ground. A series of dots is pricked out with an etching needle, so arranged that they represent the design to be engraved. It is particularly suitable for representing fancy, i.e. sentimental or figure subjects. Thus pencil drawings come out very well especially when the lines are soft and ill-defined, as pure stipple is composed of dots only.

c

Although the technique was known to the Old Masters, it was not till the latter half of the eighteenth century in England that the process came into its own. The process is stated to have been introduced here by William Ryland, a pupil of François Boucher. The French, earlier in the century, devised a technique of crayon engraving which aped the qualities of a pastel drawing. Francesco Bartolozzi, an Italian who settled in Greenwich, became the most celebrated exponent of the new technique, using it mostly to reproduce the sentimental works of Angelica Kauffmann, Richard Cosway or Giovanni Cipriani. Early in the twentieth century, colour stipple engravings by Bartolozzi after Wheatley, Morland or Westall were realizing more at auctions than the original paintings or drawings themselves. Many of Bartolozzi's twelve hundred plates were preserved after his death so that unscrupulous dealers were able to retouch the plates and produce weak and pirated impressions that do harm to the fresh, innocent delight of the engraver's subjects.

Perhaps *The Cries of London*, after Wheatley, provide the best known series in stipple. Great care is, however, needed to discern the many skilful forgeries that exist, some printed in France. This set of thirteen plates exists either in brown or colour and can reach exceptionally high prices when genuine.

Many stipple prints have been produced by a photographic process. To detect the forgery, the print should be removed from under its glass and scrutinized in strong daylight. In genuine prints, the dots stand out in clear relief, and there should be a plate-mark. If photography has been used the surface is likely to be flat and smooth.

A collector seeking good quality work in stipple could look out for works by the following artists:

Francesco Bartolozzi, Antoine Cardon, Thomas Cheesman, Thomas Gaugain, John Jones, Charles Knight, William Nutter, Daniel Orme, Thomas Ryder, Luigi Schiavonetti, John Raphael Smith, Peltro William Tomkins, Giovanni Vendramini, Caroline Watson, Charles Wilkins.

Stipple engravings are a branch of the fine arts where prices have

sometimes declined since the beginning of the century. Certainly up to the mid-1920s they tended to be over-valued. A very fine impression in colours of *Miss Farren* by Bartolozzi, after Lawrence, was sold at Christies in 1920 for £1,312. A tenth of this sum would be a good price today.

Most subjects of stipple engravings tend to be decorative. The titles are usually sufficiently indicative of the subject matter: *How sweet the Love that Meets Return*—Gaugain, after Morland; *Love and Beauty* (The Marchioness of Townsend and her son)—Cheesman, after Angelica Kauffmann; *The Scholar Rewarded* and *The Dunce Disgraced*—Knight, after Stothard; *The Lovely Brunette*—Wilkin, after W. Ward; *The Young Fortune Teller*—Gaugain after Richard Westall.

Stipple is very much to the taste of pre-Industrial Revolution society. Redolent of the Vauxhall pleasure gardens or Bath, its special charm is not without impact on the jaded palates of today.

AQUATINTS

The aquatint process provides an extension to the etching principle, by the addition of washes to the etcher's lines. It is sometimes referred to as painting in acid, providing a transparent tone in a near imitation of water-colour. It was accordingly adapted to those subjects which needed both delicacy and depth. Although known in the seventeenth century, the process appears to have been abandoned until it was rediscovered by the engraver Jean Baptiste Le Prince in 1768. It is technically very difficult to bring off and the work involved is laborious with successive bitings-in of acid which produce the different washes. Sometimes, in England, engravers used one plate to ink areas in different colours and then added extra colour washes on the impressions, after printing.

Paul Sandby seems to have been the first well-known artist to have practised in aquatint with his *Twelve Views in North Wales*. Thomas Malton, a detailed and accurate topographical artist, followed soon afterwards with views of London and Oxford.

The young German carriage designer, Rudolf Ackermann, who opened up his shop in 1795 in London, made his name and fortune by marketing the flow of sporting and topographical aquatints. He was not an engraver himself but he knew how to choose and encourage competent artists. The *Microcosm of London, Histories of the Oxford and Cambridge Colleges,* and *Public Schools* are among the large numbers of volumes published with aquatint plates.

Equally attractive, if less well known, are the works of William Daniell who spent long years in India. He produced *Oriental Scenery, Windsor and Eton Views,* and eight volumes entitled *Voyage round Great Britain.* The fine gradations of tone apparent in these impressions suggest that they represent the high water mark of this particular medium.

Such complete volumes are, obviously, out of most collectors' price range. Yet the collector is bound to come across loose plates, often of hunting or sporting subjects. He should be able to distinguish modern photographic reproductions but it may be difficult to differentiate between an aquatint and a lithograph. As a rough guide, if there is a plate mark, the print is an aquatint.

Artists who worked in aquatint in addition to those already mentioned, include: Henry and Samuel Alken—sporting subjects; W. T. Bennett—American scenes (rare); James Bretherton—a publisher for most of the time; John Cleveley—naval subjects; Daniel and Robert Havell—stage coaches; John Hill—American views (scarce); Samuel Howitt—sporting subjects; Charles Hunt—horses and stage coaches; John Harris—horses and stage coaches; Francis Jukes—American scenes, topography, figure subjects, hunting, genre; Philip de Louther-bourg—naval views, *Picturesque views of England and Wales*; James and Robert Pollard—stage coaches, sports (Plates in mixture of etching, line and aquatint); R. G. Reeve—stage coaches, schools, sporting subjects; Thomas Sutherland—coaching, sporting and military subjects.

The collector who intends to specialize in aquatints would be wise

to declare his interest to the reputable specialist firms. A good impression of a plate is important since after about fifty "pulls" the paper on which the impression was produced began to deteriorate. It was usual to make about two hundred impressions of a first issue. If good quality paper was used, the date is often visible in the watermark.

In eighteenth-century France, a more sophisticated process based on aquatint was evolved. Artists such as Debucourt and Descourtis printed from several plates. They were colour-print makers who refined the earlier mezzotint colour process of J. C. Le Blon. Louis-Marin Bonnet's superb *Tête de Flore* was recently seen in London. Bonnet used eight plates to print thirteen tones.

LITHOGRAPHS

This process is neither a relief on wood nor an incision in metal, but a surface printing invented in early nineteenth-century Germany by Alois Senefelder. It depends for its success on the mutual antipathy of grease and water. The artist makes his drawing with a greasy crayon on a special stone which absorbs the greasy content. When the stone is wetted, it absorbs the water except where there is grease present. If the stone is run through a press, an exact replica of the original drawing comes out and so much like the drawing that an unwary and unbriefed purchaser may think that he has the drawing itself and not a print.

When lithography is properly handled, the results can be splendid. Richard Parkes Bonington, Thomas Shotter Boys, Géricault and Delacroix all adopted it as a medium in its early days, and, indeed, it was taken up by artists of the most diverse backgrounds. An unlikely recruit who adopted lithography warm-heartedly was Toulouse-Lautrec, who produced over three hundred and seventy lithographs in the last ten years of the nineteenth century. Daumier and Gavarni used it to perpetuate their social satire, the impressionist Manet, the eccentric Odilon Redon and, of course, Whistler, all produced lithographs. Among its more unusual flowerings are the glorifications of

Wagner and Schumann by Fantin-Latour and the black self-portraits of Edvard Munch.

If it is possible to decipher a decline in its popularity among artists between 1820–1880, then the present century has seen a revival of the technique. Matisse, Picasso, Braque, Bonnard, Chagall and Léger used it often. Fine examples by the two last-named can be seen at the splendid new Fondation Maeght at St. Paul de Vence in the Alpes Maritimes. There is also the important German school, including Louis Corinth, Max Liebermann, Paul Klee, Oscar Kokoschka and Wassily Kandinsky.

If the recital of such impressive names frightens the modest collector, then he can be reassured because fine examples exist from so-called lesser men. Among them are: Eugene Isabey—French scenes of the *Massif Central*; James Duffield Harding—French and Italian Scenes; William Delamotte—English topography; T. G. Dutton—marine subjects; Richard James Lane—a splendid early Victorian lithographer, especially of actors and actresses; Edward Lear—topography; Sir William Rothenstein—portraits; Charles Shannon—figure subjects; Samuel Prout—topography; Charles Hullmandel—topography; Louis Haghe—topography.

A derivative of the process is known as *chromo-lithography*. Until quite recently this was disregarded as of no artistic importance, yet it was clearly evolved to meet the desire to print in colour. The first man to pass beyond the experimental stage was the Frenchman, Godefrey Engelmann in the 1830s. The printed books of the 1860s containing fine examples of these prints are now highly prized. They may be over-rich to some tastes, especially when they are of the nature of the German style "oleographs" with a simulated canvas finish. Nevertheless, despite the crudity of some of the colouring, these chromo-lithographs appeal rather more than the monotonous earlier lithotints of Hullmandel and Haghe. Examples of this latter technique can be found in volumes devoted to the travels of David Roberts and John Frederick Lewis in the Middle East and Spain. For the collector interested in

chromo-lithography, one of the most reputable firms who used this method in the mid-nineteenth century was Day & Son. R. C. Carrick was one of their better artists working after Turner in his *Rockets and Blue-Lights*, and, so, of course, was the popular late-Victorian standby Myles Birket Foster. In *Pictures of English Landscape*, and *Gems of Modern Art*, or *Brittany*, a series of landscapes plus costume and architecture studies, the collector interested in chromo-lithographs will find much to satisfy him. Other handsome volumes include *Gray's Elegy*, published in 1869 by Sampson Low, Son and Marston, with drawings by E. M. Wimperis and R. P. Leitch printed in colours by Cooper, Clay & Co., or *Gems of Nature and Art* of c. 1860, published by Groombridge & Sons, including some of the finest flower and bird plates of Fawcett. Popular works like Thomas Moore's oriental romance *Lalla Rookh* (Routledge, 1868) sometimes include a chromo-lithographed frontispiece.

The revival of interest in this medium is not confined to England; in France, too, there have been recent significantly titled exhibitions— *Rehabilitation du Chromo*.

3

Some Different Categories of Print

Just as it is possible to differentiate between prints according to the different technical processes used, so may they be classified by subject matter. This is the way of the sales-room, which tends to use such terms as "Old Master Engravings", "Sporting Prints", "Naval and Military Subjects", "Decorative Prints" and "Views", among others. An individual collector can establish his own thematic collection, so that a surgeon may seek out prints illustrating operations, or a local museum may try and build up a collection of topographical prints of the particular area it serves. Some broad categories are universally accepted; nearly all lack precise definitions.

OLD MASTER PRINTS

The earliest Old Master prints exist almost wholly in museums and are devotional woodcuts made in Germany and the Low Countries in the early fifteenth century. They often reflect the mediaeval pre-occupation with death, which is depicted as coming to claim both printer and bookseller. Thus the British Museum possesses a late Venetian engraving of the fifteenth century, after Petrarch's *Triumph of Death*. Many of these early prints relate stories from the Bible and it was one of the incidental blessings of the Renaissance that it enabled print makers to revive in graphic form the old half-forgotten legends and myths. From the viewpoint of the collector, the starting point of print-making is to be found with the woodcuts of Albrecht Dürer, who began making prints in the 1480s.

At the other end of the time scale it is possible to find works by Gainsborough and Goya in a sale catalogue devoted to Old Master Prints, but it is rare for many prints turned out after about 1750 to be included. Even so, this allows two and a half centuries of print-making for the collector wishing to make purchases in this field and many old time connoisseurs took advantage of this. Most private libraries of the nineteenth century had their own collection of Old Master Prints although such prints tended to be dispersed earlier in this century when print-collecting was experiencing a boom. Until the early 1960s, Old Master prints were a drag on the market but the resurgence of interest in them has been such that auction prices have multiplied, on average, eighteen times between 1951 and 1967, and this is an increase greater than that achieved by Impressionist paintings.

Unfortunately, even within our self-imposed limits, the buying of Old Master prints can be a tricky business. There are wide varieties in style, quality and value. One of the main reasons for this has been the failure by print-sellers, until recent times, to cancel old plates. Thus, early in this century, an issue was made of Rembrandt etchings from reworked plates. These prints are still sold but they can hardly be mentioned in the same breath as the master's own work which commands exceptional prices. His *Crucifixion* was sold for £30,000 in 1967.

It is, however, usually only the earliest impressions taken from a plate that are the most valuable. These may be worth several thousand pounds, while later impressions of the same plate may fetch only small sums. Only in the case of scarce prints is the question of condition relatively unimportant. And yet, having said this, times are changing rapidly. Prints that would have been rejected a short time ago as poor impressions, cut close to the plate mark, are now coveted. This is simply because the supply of prints in first-class condition is drying up and the demand by the market is increasing.

The fifteenth-century German masters are sometimes only known by their initials. One engraving, by an exponent who signed himself

with the letter M, sold for £4 10s. in 1834 and realized £13,000 (36,400 dollars) in 1966. *The Women's Bath* by the Master P. M. was sold for the even higher price of £32,000. We know almost nothing of these old artists, some of whom have picturesque names, like The Master of the Anchor, so-called because of an anchor-like device which appears on prints ascribed to him between the letters "B" and "R". The Master of the Days of Creation, believed to be the same as the Master of the Banderoles, is so-called because of the scroll-work he introduced into most of his prints; there is the Master of the Crab and the Master of the Die, who marked his prints with a small cube or die. The Master of 1515 is an Italian about whom nothing is known, and it is not even clear whether the prints ascribed to him can be properly catalogued under his name. Even more whimsical are the titles of the Master of the Playing Cards, the Master of the Mouse-Trap and the Master of the Garden of Love.

The layman is, therefore, at considerable risk if he blunders un-briefed into this world; to know where he is means that he must trust to reputable specialist dealers, people like P. & D. Colnaghi & Co. of 14 Old Bond Street, London W.1, or Craddock & Barnard of 32 Museum St., London W.C.1, or Mr. Christopher Mendez of 7 Great Queen Street, London W.C.2. General antique dealers may, in all honesty, sometimes be lacking in the special expertise required by this subject which is of unusual complexity. Certainly the auction room is a pitfall for the unwary and it is not recommended that the Old Master collector purchase these until quite a late stage in his development. Most people, for instance, would be content to buy an old master print at one of Sotheby's regular sales, but even that firm's carefully prepared catalogue contains the following note printed before the standard conditions of Sale:

> "Care is taken to ensure that any statement as to authorship, attri-bution, origin, date, age, provenance and condition is reliable and accurate, but all such statements are statements of opinion and are not to be taken as statements or representations of fact."

Of course, by purchasing in the sales-room the collector saves the dealer's profit margin and this can be considerable at even a low level. Thus the *Head of a Man* etched by José de Ribera sold at auction in late 1967 for £25, in a lot with a second etching. A few months later it was on offer at £45. The original seller of the print did not receive £25 because this would be subject to the auctioneer's 15% commission. The moral is clear: the collector who wishes to obtain his prints as cheaply as possible must study his subject until he knows as much as the specialist dealers. On the other hand, it is only fair to say that prices can be pushed upwards by the foolish or the unwary at auction, and the purchaser might well have bought cheaper and with less fuss direct from a dealer.

One of the advantages of a collector specializing in Old Master Prints is that the field is wide. He can leave the Rembrandts, the Dürers, the Cranachs, and the Goltzius's to the rich and the American museums. A large number of impressions are still well within the reach of the modern collector. For instance, at under £20 (48 dollars), Christopher Mendez has had on offer (Summer 1968): *A Battle Scene*—etching by Ercole Bazzicaluva, fl. 1638–1661; *Francesco de Medici*—etching by Stefano della Bella, 1610–1664; *River Landscape with a Rabbit*—etching by Abraham Gemoels, 1640–1723; *The Supper at Emmaus*—etching by Josef del Castillo, 1737–1793.

On the other hand, even the uttermost novice could hardly have gone wrong had he bought Lot 5 at Sotheby's Old Master Engravings sale of 10 October 1967. He would have paid £1 and acquired ten engravings, all laid down, of works by various artists after Sir Anthony Van Dyck and including *The Triumph of Silenus* by S. A. Bolswert.

Generally speaking, the outlook for Old Master Prints seems very good. As paintings and drawings become scarcer and more expensive, there seems little doubt that a strong demand will continue. Recent years have shown a rise in popularity of the grotesque and exotic, as exemplified by the works of artists like Bosch and Brueghel, and ten years hence we'll probably be lamenting having spotted but not

bought the unfashionable Old Master who will have made an equally rapid rise to popularity.

A category of Old Master Print that can be dealt with separately is engraving in chiaroscuro (*chiaro*=clear; *oscuro*=dark in Italian). This was a difficult technical process by which one or two colours (blue, ochre or green) were added to an engraving in black and white by making two or three impressions in succession. On the first block, which could be either wood or metal and was called the "outline block", the outline of the subject was engraved. An impression was taken from this and a second block was applied to put in dark shades. Then came a third block for light shades and, perhaps, even a fourth or fifth for extra detail.

The blocks could produce both gradations of the same colour or form different colours and the object of the whole laborious exercise was to imitate the drawings of the Old Masters.

Examples of chiaroscuro work can be very attractive but care needs to be taken as some prints of this type were produced hastily; it will be obvious that the technical process is complex and needs both patience and skill. The work of the early sixteenth-century Italian, Ugo da Carpi, is usually considered to represent the high water mark of chiaroscuro, but there are other worthy names, including Andrea Andreani, Bartholomeo Coriolano and Nicolo Vicentino. Da Carpi's chiaroscuros are usually printed in sepia, green and plum.

There was also an early German school who worked mostly on metal, including Cranach, Dürer and Goltzius. In eighteenth-century England, two wood engravers, John Baptist Jackson and Elijah Kirkstall, produced prints by imposing colour on colour from wood blocks and although they are often considered as early colour printers, in fact their works are akin to chiaroscuro. Jackson was an early manufacturer of wallpaper.

The process seems to have been abandoned around the 1800s but towards the end of the century there was a muted revival mainly among book illustrators.

44

"The Beheading of St. John the Baptist",
woodcut by Lucas Cranach the elder
(*British Museum*)

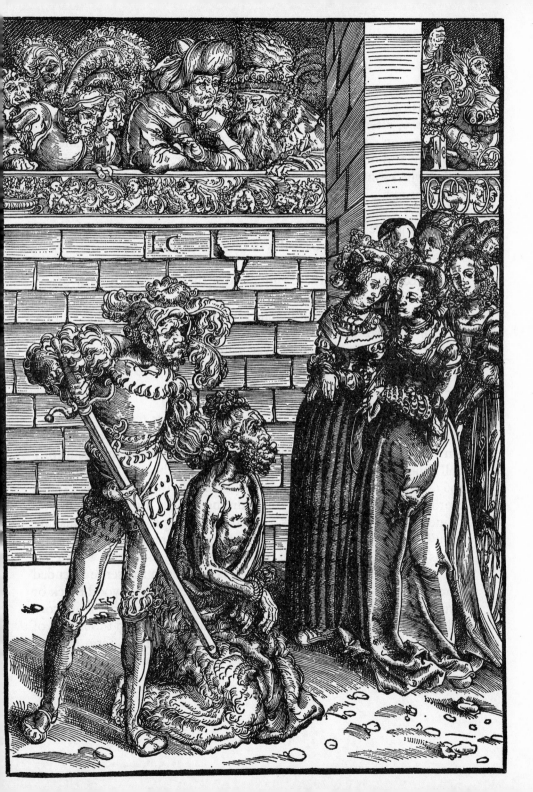

Examples of chiaroscuro woodcuts were on offer recently in London by Christopher Mendez. Specimens included:

Diogenes, after Parmigianino by Ugo da Carpi. Good but repaired impression. £120. (Printed from four blocks—three shades of brown and one black), *The Death of St. Peter, Martyr*, after Titian by J. B. Jackson £15. (Printed from four blocks in two shades of grey and brown).

The Sun-God in his Chariot, after Farinato, by Nicholas Le Sueur. An excellent French chiaroscuro—£12. (Printed from four blocks in brown, green and two shades of olive-brown).

St. John the Evangelist, after Parmigianino, by John Skippe, a talented amateur. £18. (Printed from three blocks in dark green, light green and yellow).

The Boymans-Van Beuningem Museum of Rotterdam held an exhibition of chiaroscuros in Spring 1966 and this has helped to repopularize them among collectors ever watchful for new trends.

MODERN PRINTS

It is when considering what for want of a better term we may refer to as "modern prints" that we realize how confusing the word "print" can be. Thus, *The Times* in February 1968 announced the result of a poll conducted among print-sellers to discover the ten "top prints" of 1967. The print of the year was *Horn Abeam* by Montague Dawson, a reproduction of the artist's oil painting of Sir Francis Chichester rounding Cape Horn. This is a mechanically reproduced "furnishing print" and such a phrase is not meant to be disparaging. At £3 11s. 3d. it was undoubtedly cheap, but it does not qualify as a print within our terms of reference. It is once again stressed that in the sense intended here, a print is a work produced from a copper plate, a wood block or a stone *upon which the artist has himself worked.* This excludes from consideration the reproduction which has been produced in thousands of copies by involved mechanical means. The use of the term "print" for this reproductive process can lead to confusion and, sadly, some-

times dishonesty. The term "facsimile" would be clearer, implying, as it does, a mechanical fidelity to the original. Such a reproduction may be pleasant for the decoration of a blank wall or useful for instruction in the classroom, but it is a simulation brought about by a cross between printing and photography. The artist who makes an original print thought out the entire process himself, choosing, correcting and supervising the whole, just like a painter standing before a canvas or water-colour. Some of the facsimile producers have even been known to simulate brush strokes in their desire to achieve a faithful likeness.

It is much more satisfactory to aquire an original modern print and, nowadays, choice is not lacking. There has been a revival of print-making in this country since the early 1950s and the classic processes which have already been described have all been used. Additionally, screen printing has been popular, especially in the United States, where it is sometimes called "serigraphy". There are various techniques but, basically, a piece of silk stretched over a wooden frame is placed on paper. Coloured inks are then pressed through the silk by a "squeegee". As some parts of the silk have been rendered impermeable previously by the artist, only those portions that he intended receive the design. The process is widely used in commerce for posters, labels, showcards and fabrics.

Editions Alecto & Curwen Prints of London specialize in the production of modern prints. To underline the fine quality of the work they produce, Editions Alecto have marketed an edition of 65 portfolios of "As is When" by Eduardo Paolozzi, each portfolio containing twelve prints and every print in different colours from the equivalent print in every other portfolio. However, as photography was involved —photomontages were prepared—there has been some question among purists whether they qualify as original prints.

In the sales-room, a sale of modern prints may include items produced in both the nineteenth and twentieth centuries, but even if this is rather too all-embracing there is little doubt that works by Picasso, Braque and Klee, Munch, Rouault and Chagall, qualify just as

acceptably as David Hockney of "Pop Art" and Bridget Riley of "Op Art" fame.

English collectors are lucky in the wide choice of dealers available to them (see Chapter VI). Among the most important is Marlborough Fine Arts of Bond Street, London. John Piper, Victor Pasmore, Ceri Richards and Sidney Nolan are among the major artists whose work can be seen there.

Both Marlborough and Alecto publish limited editions. A collector takes pleasure in knowing that he has Copy Number 17 of an edition of 75. Presumably, the argument runs that he would be less pleased if he owned Copy Number 17 of an edition of five thousand. Of course, with such a large edition the price would come down, but that may be another story.

Additionally, these carefully numbered limited editions may be signed by the artist. The collector should notice the difference between a signature "in the plate", when the signature is printed simultaneously with the picture, and an individual signature provided subsequent to printing by the artist. The latter suggests that the artist was aware of the preparation of the print and approved the result, but be careful —signatures can be imitated and photographic reproductions have been known to deceive the unwary. Clearly, there is a vast difference in value between a signed Picasso print, for instance, and one unsigned. The former may be worth £500; the latter £15 or less. Knavery abounds in all fields of the fine arts. Readers may recall the Norwegian art scandal where there was a suspicion that some of the lithographic stones of Edvard Munch had been used to make further prints after his death and that false signatures were appended. A Munch print in 1945 sold for £100–150. The same print today may be worth fifty times as much. A fine example of a Munch lithograph printed in four colours was recently sold in London. This was *Das Kranke Mädchen* (The Sick Girl), dating from 1896.

There may well be collectors who are looking for a modern print of a more classic mould. For the modern collector, Folio Fine Art Ltd., of Stratford Place, London W.1, is an address to note along with

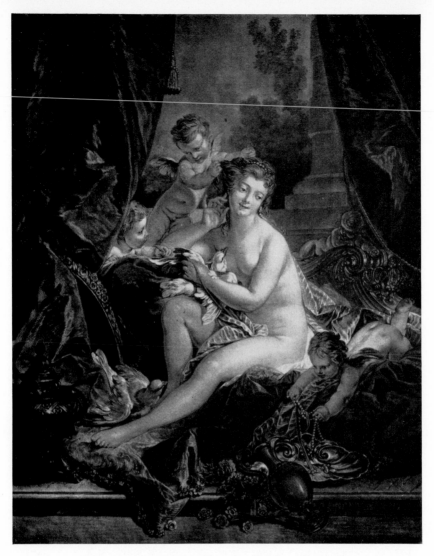

"The Toilet of Venus", aquatint in colour after
Boucher by Jean Janinet

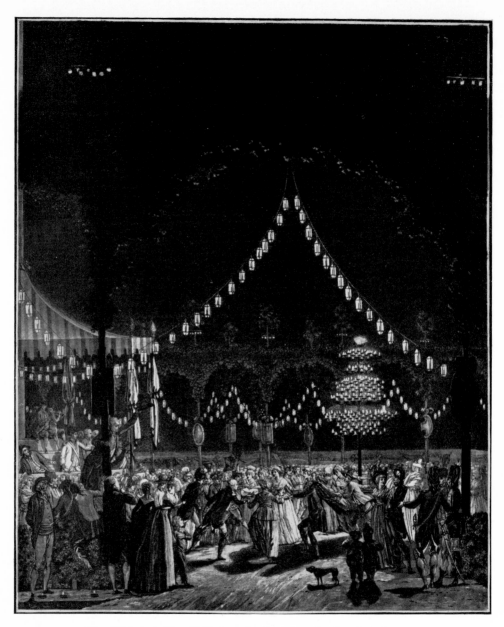

The "Bal de la Bastille", aquatint in colour by Louis le Coeur

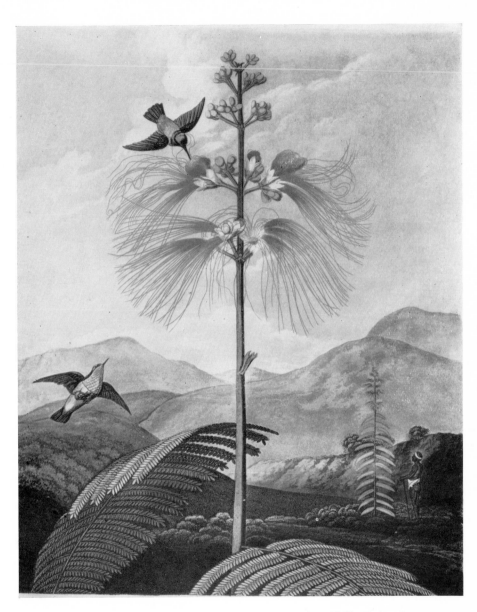

Colour mezzotint by Joseph C. Stadler after Philip Reinagle

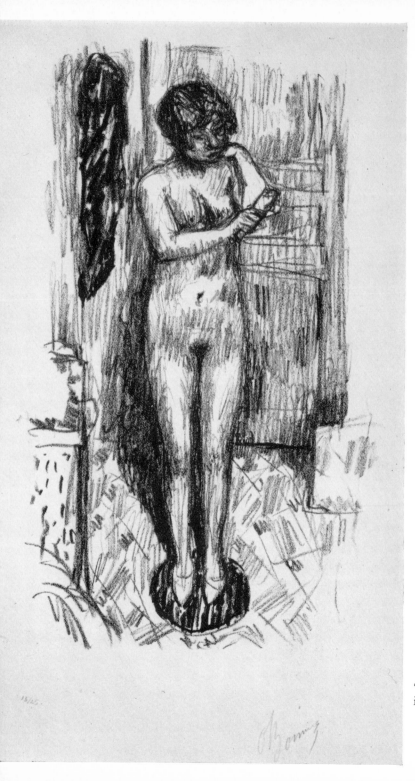

18/25

SBonnnz

"Young girl after Bath-
ing", lithograph by Pierre
Bonnard

Craddock & Barnard of 32 Museum Street, London W. 1. Of course, there is one important difference between most of the fine impressions of Cézanne, Degas or Ernst that they will show you and the prints produced by the process referred to earlier—and that is colour. Not every collector is sufficiently educated to accept the discipline of black and white and it is sad to see so many people taken in by shapeless blobs of garish colour, thus ignoring the true artistry of the burin.

Works in black and white by the three artists referred to were sold at Sotheby's in January 1968 with the following results: Cézanne— *Guillaume au pendu*, etching £22; Degas—*Aux Ambassadeurs*, etching and aquatint £20; Ernst—*Composition with two Figures*, etching £22.

These prices are hardly excessive at present-day values. Gradually it is hoped that the public, with its growing interest in contemporary graphic art, will become instructed up to a level to want, without prompting, fine quality original prints by modern artists regardless of whether they are in black and white or colour. One of the oddest statistics of this year was the revelation that a best-seller at the National Portrait Gallery is a postcard-sized facsimile in colour of Holbein's portrait of Henry VIII! More than 3,700 copies have been sold.

Colour Prints

The collector must distinguish between those prints which are produced in black and white and subsequently coloured by hand and those printed in colour. Many of the old-fashioned coloured maps offered for sale come into the former category, as do many topographical views. As colour prints are enormously popular it is especially important to obtain a fine impression. Generally this means paying the appropriate price; colour prints offered on a street corner for a few pounds are pretty well bound to be reprints—modern impressions taken from an old plate—or photographic reproductions. Some of the latter now being sold were given away as illustrated supplements to art magazines at the beginning of the century.

The credit for the invention of printing etched landscapes in colour

is usually attributed to Hercules Seghers, an early seventeenth-century Dutch painter. He worked from copper and almost all his etchings are rare and in public collections.

Jacques Christophe le Blon subsequently discovered a process of printing in colour from mezzotint plates, but with so little worldly success that he died destitute in 1740 in a Paris hospital. Basically, he used three plates inked with red, blue and yellow and superimposed them on the same piece of paper. These primary colours thereby produced a colour range. Sometimes he used a fourth plate if he wanted his blacks to be pronounced. Most of his prints have now disappeared and one explanation offered is that they were varnished and framed as oil paintings, in which guise they may still exist. Unfortunately, as photo-mechanical processes were lacking, Le Blon's method proved unsatisfactory.

During the rest of the century, French colour engravers used either aquatint which has already been described, or the "*manière de crayon*". Developed by Demarteau and Louis-Martin Bonnet, the plate was worked on with roulette tools both on the bare copper and through an etching "ground". This produced a dotted line like a chalk line on drawing paper. Bonnet developed the process to imitate pastel drawings and his most elaborate print and masterpiece was the magnificent *Tête de Flore* for which he used eight plates to print thirteen tones.

It was not, however, till about 1770 that the great age of colour printing began. The technique followed was to use one plate engraved in either mezzotint or stipple, painted appropriately with the required colours. The surface was then wiped clean. Thus an authentic stipple engraving in colour will show the space between the dots in white.

The date 1770 is significant because it meant that colour printing was introduced just before the collapse of the old order, with the onset of the French Revolution in 1789. Many colour prints are classified in the sales-room as "Fancy or Decorative Prints" and the mere recital of their titles is sufficiently indicative of the subject matter: *A St. Giles Beauty*, Bartolozzi after Miss Mary Benwell (a talented amateur artist); *Mamma, don't make me beg in vain*, Adam Buck; *L'Epouse Indiscrète*,

50

Baudouin, after de Launay; *The Mother's Hope*, *The Darling Dancing*, Freeman, after Buck; *Seductive Proposals*, Janinet, after Lawrence; *Il est pris*, Louis Philibert Debucourt.

Many may find the subject matter frivolous or insipid; others may see a charm redolent of the last years of aristocratic life in the eighteenth century.

In France at the time, Debucourt and Wille produced many prints in colour, using a process close to Bonnet's pastel manner. They would print from several plates, often on a basis of aquatint, to produce something akin to a gouache drawing. The former's *Promenade du Palais Royal* is perhaps the finest work of the period. In England, colour lent itself admirably to the fashionable stipple and mezzotint processes and artists like Bigg, Morland, Singleton and Wheatley saw their works extensively used to satisfy the popular demand.

Collectors interested in this field could, among others, seek out engravings by William Bond, Antoine Cardon, Thomas Cheesman, John Jones, Charles Knight, Luigi Schiavonetti, John Raphael Smith and William Ward.

Sales-room prices are often reasonable but it cannot be too strongly emphasized once again that great care is needed to check the freshness and authenticity of this type of engraving.

Some examples of prices at recent sales are: *Trepanning a Recruit*—stipple in colour, Keating, after Morland £18; *The Weary Sportsman*, *Shepherds Reposing*, both stipple, in colour, Bond, after Morland £55; *The Parting of Hector and Andromache*—Ward, after Emma Smith £16.

Collectors of French eighteenth-century engravings will hardly have missed the splendid exhibition of P. & D. Colnaghi & Co., of 14 Old Bond Street, London W.1. in early 1968. Jean François Janinet's fine aquatint in colour, *La Toilette de Vénus*, after Boucher, was one of many items which attracted admiring glances at the exhibition. Another well-known dealer who handles this type of print is F. B. Daniell Ltd., 32 Cranbourne Street, London W.C.2.

In nineteenth-century England, colour printing continued to exert a fascination despite everything that was said and written about the

quality of the black-and-white engraving. The most original and brilliant of the mid-Victorian colour printers was George Baxter who patented his special method in 1835, making use of oil colours ground from the same materials as painters in oil. His aim was to achieve "picture painting in colours" and, under his conscientious, personal supervision, a number of oil-like prints were produced. Their brilliance is characteristic and distinguishable from the later more garish chromolithographs.

In addition to this typical colouring, the collector can recognize a Baxter print by the presence of the following words printed on the picture or embossed on the mount: "Painted in oil colours by Geo. Baxter, Patentee" or "Printed by G. Baxter, the Inventor and Patentee of Oil Colour Painting". His various addresses in London also help to date his prints: 1830–1835, 29 King Square; 1835–1843, 3 Charterhouse Square; 1843–1851, 11 Northampton Square; 1851–1860, 11 & 12 Northampton Square.

Baxter represents the Victorian who, with the advance of mechanical inventions, sought to achieve a more popular application of the art of colour printing. He achieved considerable success but not in financial terms. His two most celebrated prints are considered generally to be *The Coronation of Queen Victoria 1838* and *The Opening of Queen Victoria's First Parliament*. Other categories of Baxter prints include the following: (The figures in parentheses refer to the catalogue numbers in G. Courtney Lewis' *George Baxter, the Picture Painter*, the standard work for all Baxter enthusiasts).

Missionary Prints
 The Massacre of the Rev. J. Williams (826)
 Te Po, a Chief of Raratonga (79)

The "Great Exhibition" of 1851 Series
 The Crystal Palace and Gardens (193)
 Gems of the Exhibition (191)

Crimean War Prints
 The Soldier's Farewell (200)
 The Siege of Sebastopol (199)

Portraits of the Famous
 Queen Victoria (216)
 Napoleon I (224)
 Prince Albert (210)

Religious Prints
 The Descent from the Cross (236)
 The Holy Family (234)

Interiors
 Stolen Pleasures (272)
 The Bridesmaid (260)

Flowers and Fruit
 The Gardener's Shed⎫ very popular and often forged. (275)
 Hollyhocks ⎭ (276)

Exteriors
 The Lover's Letter Box (359)
 Come, Pretty Robin (349)
 The Ascent of Mont Blanc (336)

The number of colour blocks required to produce these prints varied from between twelve to thirty and Baxter showed considerable technical skill in engraving.

On the expiry of Baxter's patent, several people were licensed to work his process. Abraham Le Blond was the first and best known licensee. Many of Le Blond's prints were oval and of rustic scenes— cottages and churches or of childhood memories. They can be thoroughly charming. His reprints of Baxter's plates were less

successful and in 1888 the stock was sold to a Mr. Mockler who helped found the short-lived Baxter Society. In 1896 everything was put up for auction in Birmingham and dispersed.

There have been many forgeries of Baxter prints, some modern. Even the mounts have been forged as unmounted prints were less valuable. It may be useful to scrutinize a Baxter print with a strong magnifying glass; a forgery may have its surface covered with a fine trellis-like pattern.

With Baxter prints, collectors are advised to seek out clean, undamaged prints, with no tears or creases. Baxter's later less ambitious productions, pocket-sized prints or Sunday School cards are less valuable. These are sometimes referred to as "needle prints" like the *Queen's Floral Needle Box Set* or *The May Queen Set*.

It is difficult to provide a guide-line to Baxter print prices. So far, they have not been seen often in the sales-room and then only in mixed lots. As, however, the Stevengraph silk pictures of an even later date now warrant their own specialist sales, it may not be long before the same is true of Baxter prints.

An extensive collection of Baxter prints is held by Reading Museum and Art Gallery.

CARICATURE AND SATIRE

Satire is an older weapon than it might seem, and as far as a school of satirical engraving is concerned England stands almost alone. Caricature and satire are not, of course, quite the same thing. Caricature derives from the Italian word "caricare", to load, and the word implies exaggeration, often of a gross or grotesque nature. Such qualities need not necessarily be present in visual satire.

The first important figure to note is William Hogarth, although from the standpoint of technique he is not in the first flight of engravers, having a quality of haste and unevenness in his prints which is often only too apparent. Hogarth was essentially a teacher and moralist. He wanted to ram home to the least educated members

of society the particular message he had in mind. Several of his works are conceived on a large scale and are meant to be hung together on a wall so that they could be seen at a distance. At the Sir John Soane Museum in Lincoln's Inn Fields you can see the effect he had in mind by viewing the six oil paintings comprising *The Rake's Progress*. Rapid, bold lines were more important than delicate artistry. His purpose is underlined by the cheapness at which he sold his prints, which was also intended to frustrate the many pirate copies of his prints.

The success of his large-scale engravings—*The Harlot's Progress, Industry and Idleness, The Rake's Progress*—means that the collector must be careful not to be taken in by the many reprints and reproductions that exist. In his desire to drive his moral message home, Hogarth left much of his work for other engravers to reproduce—*Calais Gate* by Mosley and the *March to Finchley* by Sullivan for instance. There have been many editions of his prints, one of the best being taken from the original plates in 1822 by Baldwin & Craddock. This large folio contains a secret pocket which originally contained three suppressed plates, but you'd be exceptionally lucky to find them now.

Like Daumier later, Hogarth singled out certain categories of individuals as particular targets for his burin. The military, the clergy and the French are obvious examples to the extent where the over-simplification of their characteristics is too easily predictable. Virtue, with Hogarth, triumphs with uncommon regularity.

If Hogarth is the first in time of the great English caricaturists, it is to Rowlandson and Gillray that the collector must look for the full flowering. Rowlandson was a trained water-colourist, which explains his predilection for the use of coloured aquatints as a medium. It is sometimes forgotten that in addition to his caricatures he executed landscapes in water-colour and produced soft-ground etchings after drawings by Gainsborough.

Rowlandson is altogether less barbed than Hogarth or Gillray and it is confusing in some ways that his name is so often linked with Gillray's. Rowlandson is comparatively tolerant, detached, achieving his effects with a disarming kindliness. His best works were published

by S. W. Fores of Piccadilly and Rudolf Ackermann in the Strand. Later prints published in Cheapside by the bookseller, Teggs, are altogether coarser with garish colouring. His "Dr. Syntax" plates are often met with and there are three volumes of these adventures— *Dr. Syntax in Search of the Picturesque, Dr. Syntax in Search of Consolation,* and *Dr. Syntax in Search of a Wife.*

There are many forgeries of Rowlandson's work, but even on the genuine plates he often did little more than the preliminary etching. The aquatinting would be carried out by one of the many artists in Ackermann's employ. Fortunately, these were all more than competent in their own right, including men like T. Sutherland and J. C. Stadler. The published impression of the print would then be coloured by hand using as a guide a proof which Rowlandson had coloured.

Gillray is the most venomous of the English caricaturists; in particular, his savage, and, at times, obscure attacks on George III and politicians appear so concentrated that it seems astonishing that some saw the light of day. Yet he was a professional and, unlike Hogarth and Rowlandson, regarded caricature as his vocation. Sometimes much of the allusion in his work is only intelligible to the professional historian, e.g. *Dumouriez at the Court of St. James,* where not everyone is to know that Dumouriez was a French General who changed sides during the French Revolution and came to London to be dined and wined by the Government to the disgust of Gillray. We may wonder why the white-coated figure of the slim, large-nosed Archduke Charles is worth Gillray's time in providing a caricature. The Archduke was, however, one of the successful Allied commanders in the war against Napoleon, although in the 1790s his reputation was hardly yet achieved.

Despite this eclectic specialization in contemporary politics and war, and regardless of the complicated lay-out of some of his larger prints, there is a simplicity of approach about Gillray's work which is akin to much of the cartoon technique in todays' press.

The collector interested in Gillray's works, and this is certainly commendable on financial grounds, for his work is almost certain to

rise in value, should beware of the later reprints and forgeries. This state of affairs contrasts sadly with the disposal of the printseller Humphry's stock in 1835 when Gillray caricatures were sold for little more than a penny each.

Many of the single coloured plates which appear from time to time on the market have come from broken-up copies of the 1830 edition in two volumes of his completed works containing three hundred caricatures.

It is sometimes forgotten that although Hogarth, Rowlandson and Gillray dominated their age, they had many lesser rivals. The collector may meet quite frequently the plates of Henry William Bunbury, who was very fertile in producing designs which were then reproduced by other engravers, Bunbury himself not being enormously successful with the etching needle. The print dealer, James Bretherton, published most of Bunbury's prints. They include: *A Chop House* (including a portrait of Dr. Johnson); *Recruits; A Visit to the Camp; Pot Fair, Cambridge; Paysanne de France; A Visit to Foreign Parts.*

Another quite masterly etcher was Robert Dighton, whose prints like those of Gillray became less popular as the persons represented died away. Dighton's declared object was:

> *To catch the manners as they rise*
> *To shoot folly as it flies.*

He worked in St. Paul's Churchyard, known at the time as the "Caricature Warehouse" because so many printsellers set up shop there. Dighton executed a number of kindly yet pointed mezzotints in colour, aiming at what he called "the latest loose fashions of the frail sisterhood"—The Dog and Duck Tavern, The Pantheon in Oxford Street, Bagrugge Gardens and Vauxhall Gardens, were the places where these ladies of delight were to be found. By a happy chance, a number of these charming prints have passed recently through the saleroom so that there is a reasonably up to date guide as to prices. The military terms used in the titles of the following coloured mezzotints should not confuse the collector as to the nature

of the engravings, which are almost invariably about a beauty en-
countering a gallant: *An English Sloop engaging a Dutch man of war*—£20;
An English man of war taking a French privateer—£28; *The Card Party;
the Skilful Nymph reviews her force with care*—£14.

Dighton favoured all kinds of lively subjects—women playing
skittles, betting or shouting, female bruisers, or military manoeuvres;
and he was quite capable of a dig at a bumptious fellow artist. The
Prince Regent's portrait painter, Richard Cosway, was well known
for his vanity. He married an Italian which explains the title of the
print—*The Maccaroni Painter or Billy Dimple sitting for his portrait*, a
Dighton drawing engraved by Richard Earlom. Most of Dighton's
prints were published by Robert Sayer of 53 Fleet Street. The collec-
tor may come across several prints bearing his name but he was not
himself an engraver. Some of the mezzotints published by him invite
a degree of discrimination as they were sometimes the copies of other
publisher's genuine prints. This may appear less surprising when we
learn that Dighton was himself not without censure. Apparently he
made it a regular habit to abstract the choicer prints from the British
Museum's portfolios, including four Rembrandt's on which Dighton
appended his own collector's mark. Dighton's engravings and
similar "fancy subjects" are usually stocked by F. B. Daniell Ltd.,
and Sanders of Oxford, in High Street, Oxford.

Another excellent caricaturist of the same period is George Mouton
Woodward whose works are available quite cheaply in water-colour
or as etchings, the latter frequently coloured by hand. Many of his
prints and drawings consist of single figure studies illustrating a
particular idea, e.g. *Shocking* or *Delightful*. One of his most effective
sets is *The Effects of a New Peerage*, fourteen caricatures of newly-made
peers on one sheet published in colour by Fores in 1810. Woodward's
work is good-humoured, lacking the venom of Gillray. A set of his
coloured drawings, *The Effects of Flattery*, were etched by George
Cruikshank's father, Isaac. In 1796 Woodward produced *Eccentric
Excursions or Literary and Pictorial Sketches of Countenance, Character
and Country in different parts of England and South Wales, interspersed*

with curious anecdotes with 99 coloured plates. The humour is somewhat coarse and flamboyant.

In the nineteenth century after the accession of Queen Victoria caricature became altogether milder and Gillray was superseded by Cruikshank and Doyle, as they in their turn were overtaken by Leech and Tenniel, at which stage the union of caricature and the printed word was complete.

George Cruikshank, whose output both as regards talent and volume greatly exceeds that of his father, and brother Robert, possessed an enormous zest and facility for draughtsmanship. Many of his big prints suggest that they were composed by mixing up a number of differing sketches, often in an imaginative manner. Cruikshank gained fame as the illustrator of works by Dickens and Harrison Ainsworth. Cruikshank's prints are so numerous that it may well be worth the collectors while to seek out the rarer signed first proof etchings on India paper. His anti-Bonaparte prints are very effective and sometimes rare, as for instance, *The Rogue's March from Madrid to Paris*, a large coloured, rectangular caricature 42 in. long in which Cruikshank satirises the flight of Joseph Bonaparte during the Peninsular War. This is sometimes met in the form of a scroll-print, attached to a wooden handle around which it can be folded or opened out. It was designed to be passed from hand to hand for the delectation of after-dinner guests in the pre TV age. Cruikshank was also a moralist, as the eight tinted plates of *The Bottle* and *The Drunkard's Children* suggest. His prints are full of lively social comment, attacking the new industrial juggernaut which was transforming England's rural landscape.

From the technical standpoint, Cruikshank preferred wood to copper, especially for his numerous illustrations to the recently founded *Comic Almanack*.

John Leech, Hablot Knight Browne, or "Phiz" as he called himself, and who was much influenced by Cruikshank, and Charles Keene carried on in a more harmless way the profession of the caricaturist. Theirs was probably an inevitable reaction from the coarseness of

the eighteenth century, yet their work and especially that of Keene is undergoing revaluation today. Formerly they were dismissed cursorily as illustrators for *Punch*; now there is an awareness, especially in Keene's drawings, which lie outside the scope of this volume, of a greater depth of feeling.

However we evaluate them these Victorian artists must incline before the great revolutionary on the other side of the Channel who was to provide yet further impetus to the art of caricature—Honoré Daumier.

Daumier's first caricatures were of judges at the State Trials of 1832 early in Louis Philippe's reign. Daumier discovered immense possibilities in lithography as a medium and used this new-found strength to discredit the régime he detested. Has there ever been a lithograph more eloquent than *Rue Transnonain 1834*, with its blood-stained and silent corpse, victim of the repressive cruelty of the then French Government?

Daumier appears to have evolved a technique all his own, not sketching his design on the stone first, like other lithographers, but jotting down a mass of lines and shapes from which, in due course, a recognizable design emerged. Sometimes he crushed his black crayon against the stone with an old cork, or he might spray ink on the stone with a broken comb.

Altogether he produced four thousand plates for *La Caricature* and *Le Charivari* and the student of nineteenth-century France as well as the collector is inevitably drawn to consult them. Among the immense output of Daumier are the sets *Tout ce qu'on voudra* ("As you like"), *Robert Macaire*, *Men of the Law*, *Parisian types*, *Married Manners*, *Worthy Citizens*, etc. Depending on condition, a fine quality lithograph signed with the characteristic H.D. in the stone should be obtainable for between £10–15. Exceptional prints like those of the E. E. Cook collection, which was dispersed at Sothebys in 1963, fetch proportionately more.

Daumier's successor and rival, although these terms are inappropriate because the two men's careers overlapped and complemented

each other, is usually taken to be Paul Gavarni. He started life as a fashion illustrator and this is sometimes revealed in his early lithographs by the excessive attention he pays to detail. A number of his prints are of the theatre or gay life like the dandyish *Private Room at Petron's*. Admirers of Gavarni are often also drawn to the works of "Cham" (real name Amédée de Noé) while those with a taste for the bizarre will seek the work of Jean-Ignace Grandville who surrounded his engravings with small, weird figures. He, too, attacked Louis-Philippe and his ministers. Grandville's series of caricature, which are rarer to come across, were entitled *Today's Metamorphoses* and *Scenes from Animal Public Life*.

The connoisseur of caricature could, of course, come close to the present day for his choice. Very recently the talented drawings of Lewis Baumer, who worked in the early part of this century in London, were dispersed for only a few shillings apiece. It seems the fate of the caricaturist to have to await mature judgment of his quality until after his death.

Another Frenchman is Jean Louis Forain, who lived well into the present century. His caricatures of lawyers are, possibly, even more effective than those of Daumier, but then he lived at a time when scandals and crises were not lacking. When nearly sixty years of age he began to etch and produced splendidly satirical plates of French society. Examples of both types of prints are *L'Avocat Invective*, lithograph; *L'Avocat parlant*, dry-point; *La Sortie de l'Audience*, lithograph; *Maison Close*, etching; *Les Notables*, etching.

4

Collectors' Favourite Prints

Certain categories of prints are always sought after by collectors regardless of condition or state. These deserve separate treatment because there is clear evidence of popular favour.

FLOWER PRINTS

These rank high on many collectors' lists but as always, considerable care needs to be taken as things are not always what they seem. The collector who is drawn towards flowers because of their profusion of colour may not always realize that many of the impressions he so admires were printed in black and white and, subsequently, coloured by hand. There is a wide choice open to the connoisseur and perhaps the most attractive prints are those after Pierre Joseph Redouté who in the early nineteenth century was the most celebrated flower-painter of the day. He was a Belgian living in France who visited England to see the rare plants at Kew Gardens. The plates from *Les Liliacées* published between 1802 and 1816 are considered some of the best in the history of botanical illustration. Separate plates are frequently encountered like the *Twice-flowering Iris*, the *Grape Hyacinth* or *Amaryllis*. Redouté's rose prints are equally in vogue. Collectors may come across delicately-coloured aquatints by Chapuy after Redouté like *The Wild Rose*, an aquatinted line engraving exquisitely painted in colour by Remond.

Less assuming are the copperplate engravings of William Curtis who issued his *Flora Londinensis* between 1777 and 1787. Subsequently coloured by hand, these plates are of the homely plants growing with-

in a ten-mile radius of the capital. The names are familiar—*Scotch thistle* or *Bindweed*—but the effect is delightful. A French stipple equivalent to these modest flowers is visible in the *Hollyhocks* plate by Rouotte, c. 1810, after J. L. Prévost.

Copperplate engravings of a similar type and also subsequently hand-coloured were produced by Benjamin Maund between 1837 and 1846 in *The Botanist*. These plates, measuring 22.5 x 17 cms., are inexpensive but nonetheless decorative. Sample titles are *The Brilliant Fuchsia*, *The Toothed Acacia* and *The Narrow Leaved Solarium*.

The most splendid and celebrated flower plates ever produced are coloured mezzotints, finished by hand and published by Dr. Robert Thornton under the title *The Temple of Flora*. These are large plates, usually about 487 mm. x 377 mm. each, and are expensive. *Roses*, engraved by Richard Earlom, sells at auction for around £50. The finest plate in the block—*The Superb Lily* by William Ward after Reinagle—may run into three figures. Other attractive and well known plates in the volume include the *Large-Flowering Sensitive Plant* by Stadler after Reinagle. This is *Mimosa grandiflora* and it is characteristic that the plant should be placed in a wildly inaccurate setting with humming birds, a surprised-looking Jamaican and mountains in the background. An equally attractive plate is *The Pontic Rhododendron* by Caldwall after Henderson, but all the prints are rich and splendid. Most of the volumes in existence have been broken up by dealers but when a fine complete copy in good condition comes into the saleroom the bidding is brisk and furious.

Other flower prints to be found are: *Plantae et Papilliones Rarores*, by George Ehrer who came to England from Heidelberg and who published his plates between 1748-9; *A Collection of Flowers after Nature*, c. 1770, by John Edwards who imparted finish and detailed colours; *Flowers of the Months*, line engravings published by John Bowles c. 1730 and subsequently often hand-coloured. A set of twelve in average condition might realize £250–£300 today; *Primroses* by Luigi Schiavonetti after Wheatley in black, bistre or coloured stipple, one of Wheatley's *Cries of London*. All these plates have been

extensively forged and reprinted, so great care is needed, especially if a coloured impression is sought.

A less well known Cry of London—*All a-growing a-growing, here's flowers for your gardens!*—was the subject of a coloured mezzotint by Merke in 1799 after Rowlandson.

A nice pair of richly coloured nineteenth-century lithographs was issued by J. B. Prévost. They are usually met with their French names: *Vase, Verre de Couleur* and *Vase Chinois*.

The Victorians frequently included flower prints as book illustrations. Mrs. Withers, Flower Painter in Ordinary to Queen Adelaide, and Copley Fielding's sister Mary were talented water-colourists with a penchant for flowers whose drawings were frequently reproduced. The reader will, likewise, recall the two Baxter flower prints: *Hollyhocks* and *The Gardener's Shed*.

All the above flower prints are in colour. In the opinion of some critics the finest *flower piece* ever engraved is in black and white or bistre. This was the work of Richard Earlom after Jan Van Huysum and, in good condition, is both rare and costly. Earlom's technical prowess is such that the viewer hardly notices the absence of colour. This is especially true of an early impression with its full rich, velvety bloom.

A London printseller who always has a fine stock of flower prints is Weinreb & Douwma, of 92 Great Russell Street, London W.C.1. His good taste is shown by the choice of birds-eye maple wood frames for his plates from *The Temple of Flora*.

BIRD PRINTS

John James Audubon is usually considered the most celebrated of bird artists. He lived among wild Red Indian tribes for twenty-five years in order to produce his *Birds of America*, which was published between 1827–1838. Aquatints from his drawings were produced by the Havells, father and son, and these splendid impressions are now beyond the reach of most collectors. Good impressions by Robert

Above left, "A Woman of Spirit", by and after James Gillray; *right*, a rare lithograph from one of Honoré Daumier's "As You Like It" series satirising French bourgeois habits; *below*, a colour lithograph, "The Invalid Girl", by Edvard Munch

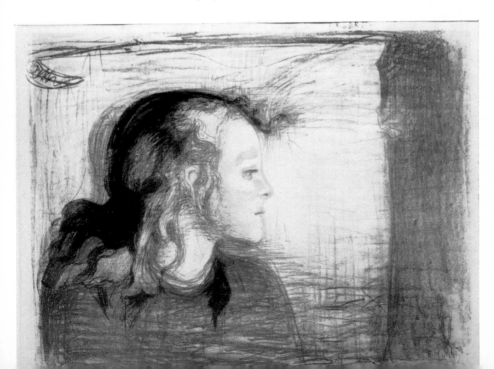

Above, "At Burnham Beeches" by Arthur Willmore after Myles Birket Foster; *below*, a partridge-shooting aquatint by James Godby and Henri Merke after Samuel Howitt

Above, "The Road versus Rail", 1845, an aquatint by John Harris after C. Cooper Henderson; *below*, lithograph of the locomotive engine house at Camden Town, 1839, by John Bourne

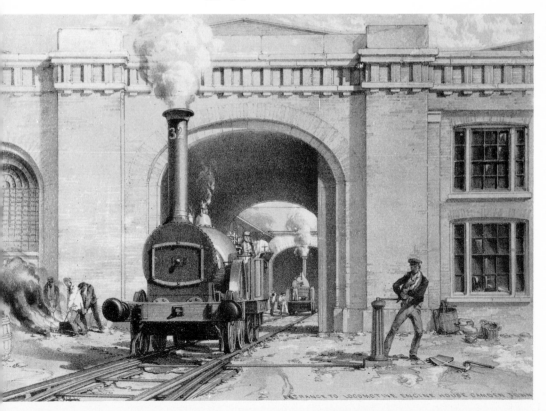

Two coaching aquatints by John Harris after C. Cooper Henderson: *above*, "The Olden Time"; *below*, "Flooded"

Havell of popular examples fetch around £100 each in the sales-room. These would include better known subjects such as, *Painted Bunting, Rice Bunting, Hermit Thrush, Chestnut Sided Warbler* and *Carbonated Warbler*.

Michael Joseph Ltd., of 26 Bloomsbury Street, London W.C.1, in conjunction with *The Connoisseur*, brought out a two volume re-issue of these plates in 1966 at 25 guineas under the title of *The Original Water-Colour Paintings by John James Audubon for "The Birds of America"*. This was, undoubtedly, a handsome bargain to be offered by an elderly godparent to his godchild because there is little doubt that this limited edition will show a steep rise in value in due course.

Another artist who produced vast quantities of bird studies was the Victorian, John Gould, who had the unusual distinction of once having Edward Lear as a lithographer in his employ.

The modest collector might do worse than look at the delightful, small wood engravings of Thomas Bewick, whose name is linked with his *British Birds*, published between 1797–1804. Single woodcuts of Bewick are quite often encountered and so much the better if there is the representation of a thumb-mark on the top margin. This mark indicates that the print was issued by Bewick himself, who contrived thus to stop his workmen taking prints from his studio and selling them illegally. Studies of birds will also be found in his *Aesop's Fables*.

Many bird illustrations were issued as lithographs and, later on in the nineteenth century, subjects were chromo-lithographed. These can be vivid if not fierce. A fine example of this type of illustration can be seen in the rare *Gems of Nature and Art* published around 1860 by Groombridge & Son and containing some fine colour plates by Fawcett of exotic species, including *Humming Birds, Brazilian Bell Bird* and *Bird of Paradise*.

A good general rule for bird print collectors is to beware of black-and-white prints coloured later and badly, by hand. The chromo-lithographs are, by contrast, honest and competent productions. Once derided, they are now sought after and understandably so.

SPORTING PRINTS

This is a self-evident group whose popularity needs neither explanation nor justification. One of the great tragedies in the field of fine arts is that there is no comprehensive public collection of fine sporting prints. One reason is that overseas collectors, especially in America, have been buying the best impressions for a number of years. According to Ackerman's, the specialist dealers in this field, another reason may be the effect of the nineteenth-century glass tax. This caused many engravings to be cut down, or worse, varnished, to avoid payment of duties. Such prints have lost a great deal of value as a result. Most sporting prints are engraved in aquatint and some of the better known examples are listed below. In good condition, they can be rare and expensive. (All prints are coloured aquatints unless otherwise stated):

Angling

Anglers of 1611; Anglers of 1811, two coloured etchings by and after H. W. Bunbury, *c.* 1811. *Fly Fishing for Trout; Live Bait Fishing for Jack,* by R. G. Reeve after J. Pollard, *c.* 1830. *The Young Angler, c.* 1803, by and after W. M. Craig—coloured stipple. *Fishermen going out; Fishermen returning,* by John Jones after C. Carter—mezzotints. *The Fishermen,* by J. Hassall and W. Nicholls after P. Reinagle, 1813. *The Drowned Fisherman,* by J. Heath, after R. Westall—line engraving. *A Boy Angling; A Boy mending a net,* by Nutter and Gaugain, after R. Westall—stipple. *A Boy Angling,* by J. Ogborne after R. Westall. *The Fair Angler,* by J. Ogborne after Wigstead—stipple. *The Anglers,* by and after J. Pierson, *c.* 1813. *Fishing,* by Charles Hunt after J. Pollard. *A Party Angling,* by George Keating after Morland. *The Angler's Repose,* by William Ward, after Morland—coloured mezzotints. *Anglers Packing up,* by R. G. Reeve after J. Pollard, 1831. *The Fisherman's Dog,* by S. W. Reynolds, after Morland—mezzotint. *Angling,* a set of six by Charles Turner R.A. *The Fishery,* by William Woollett after R. Bright.

Archery
A Meeting of the Society of Royal British Archers, by C. Opostal after R. Smirke R.A. *Greenford School, boys going to Archery; The young Archer*—mezzotints published and possibly executed by Carrington Bowles.

Bird Shooting
Partridge Shooting, by J. C. Bentley, after H. Alken. *Partridge Shooting; Grouse Shouting; Snipe Shooting; Bittern Shooting*, by J. Clark, after H. Alken 1820. *Partridge Shooting; Red Grouse Shooting; Ptarmigan Shooting; Otter Hunting; Springing Spaniels*, by F. C. Lewis after Philip Reinagle. *Poachers tossing for the odd bird; Keeper on the look out; A Hare's on the Fallow*, by R. G. Reeve after H. Alken. *Water Dogs*, by J. Ward after Ben Marshall; *The Warrener*, by J. Ward after Morland (mezzotint); *The Spanish Pointer*, by W. Woollett after Stubbs. *The English Setter*, by T. Cook and S. Smith after Melton.

Bowls
A Game of Bowls, by Eugène Chiquet after Meissonnier—line engraving.

Boxing
The Interior of the Fives Court, with Randall and Turner sparring, etched after T. Blake and aquatinted by C. Turner, 1821. *A Prize Fight*, by J. Clark after Henry Alken, 1820. *The Boxing Match between Richard Humphreys and Daniel Mendoza*, by Joseph Grozer after S. Einsle—coloured stipple. *The Great Fight between Broome and Hannan for £1,000*, by C. Hunt after Henry Heath. *Prize Fighters' Portraits*, by C. Hunt. *Deaf Burke; Johnny Walker; Bendigo. The Death and Burial of Tom Moody*, by E. Duncan and C. Rosenberg, one of four plates by J. Pollard: *The Life and Death of Tom Moody, 1829. The Fight between Randall and Turner for £100, 1818* (artist unknown). *Female Bruisers*, by Butler Clowes after J. Collet—published in mezzotint by R. Sayer in 1770 (the plate represents women fighting in Covent Garden).

Cock-fighting

The Set-to; The Fight; Throat; Death, a set of four plates by R. G. Reeve, 1825. *The Black Breasted Dark Red Champion who killed three in two minutes; The Streaky Red Dunn, called the "Bone Crusher"*, by R. G. Reeve after Marshall. *Colonel Mordaunt's Cock Match*, by R. Earlom after Zoffany, 1792—mezzotint. *Fighting Cocks*, a set of four plates by R. Pollard after J. Pollard.

Coursing

Badger Catching, by J. Clark after Henry Alken, 1820.

Cricket

Sketches of Lords, c. 1851; *United All England Eleven*—published by F. Lillywhite; *Portrait of Wisden in his cricket gear, with Brighton Church in the background*, 1853, by John C. Anderson—coloured lithographs. *Cricket at Eton College*, 1844, by Charles W. Radclyffe—coloured lithograph. *Lillywhite, the Cricketer*, published by Masons of Brighton, 1841. *Surrey Cricket Ground*, a match in progress by C. Rosenberg. *Rugby School with boys playing cricket*, by R. G. Reeve, after Pretty. *The Soldier's Widow, or the Schoolboy's Collection*, by Robert Dunkarton after William Redmore Bigg—mezzotint, 1810.

Dominoes

Playing at Dominoes, by S. W. Reynolds, after Morland—mezzotint.

Fencing

Angelo's Fencing Academy, Charles Rosenberg after Rowlandson—etching.

Fives

Rugby School Fives Court, by B. Ridge after G. Madely, *c.* 1850—lithograph.

Golf

To the Society of Golfers at Blackheath, by Valentine Green after L. F. Abbott—mezzotint. (A print which has been reproduced in exceptionally large quantities); *Henry Callender Esq.*, to the Society of Golfers at Blackheath, by William Ward after L. F. Abbott—mezzotint. *The Golfers*, by C. E. Wagstaffe after Charles Lees R.S.A., 1850.

Hawking

The Rendezvous; The Departure; Fatal Stop; Disgorging, by R. G. Reeve after F. C. Turner, 1839. *The Falconer*, by S. W. Reynolds after Northcote—mezzotint.

Hunting

Going Out; Into Cover; The Check; The Death; by Edward Bell after Morland—large coloured mezzotints. *The Grand Leicestershire Steeplechase*, by J. C. Bentley after H. Alken—eight colour plates. *The Earth Stopper; Going into cover; Breaking cover; Hounds in full cry; The Death; Digging Out*, by J. Clark after H. Alken, 1820—a set of six. *Gone Away; A Capital Finish; Don't move there, we shall clear you; A friendly mount; Mr. Jorrocks*, by John Leech, 1865–6—chromolithographs. *The Quorn Hunt: The Meet; Drawing Cover; Tally Ho! and away; The Pace begins to tell; Snob is beat; Full Cry, Second Horses; The Whissendine appears in view; The Death*, by F. C. Lewis after H. Alken—a set of eight. *The Death of the Doe*, by and after George Stubbs, 1804—mezzotint. *Going Out; Breaking Cover; Running; The Death*, by T. Sutherland after Dean Wolstenhulme, 1823.

Marbles

Boys playing at Marbles; Boys playing at Peg Top, by R. Pollard, after Paye—mixed etching, line, and aquatint. *Two boys playing marbles*, by John Murphy after James Ward—mezzotint.

Pigeons

Portraits of Baldheads, two pigeons presented to the Feather Club, by and after David Wolstenholme; *A Few Knowing Fanciers at an Evening Pigeon Show,* by T. Sutherland after S. Alken 1823.

Racing

The Last Horse Race run before Charles II of Blessed Memory, 1684, by and after Francis Barlow, 1689 (The earliest known racing print). *The extraordinary steeplechase between Mr. Osbalderton's "Clasher" and Captain Ross's "Clinker",* by E. Duncan. *Returning from Ascot Races,* after C. Henderson, 1839. *Blair Atholl,* winner of the Derby, 1853, by J. Harris after Henry Hall. *Eclipse,* by C. Hunt after G. Stubbs. *The Queen of Trumps,* by C. Hunt after J. F. Herring. *The Brown Horse "Mask",* by and after Stubbs. *"Ebor",* by T. Sutherland after J. F. Herring. *The High Mettled Racer,* by T. Sutherland after H. Alken—six plates. *Mr. G. Osbalderton riding his horse against Time,* by J. Harris after Pollard 1831. *Scenes on the Road to Epsom; The "Lord Nelson" at Cheam; The "Cock" at Sutton; Kennington Gate; Hyde Park Corner,* by J. Harris, 1838; *Epsom Downs on Derby Day,* after Alfred Hunt—a fine example of mid-Victorian colour printing from twelve blocks. *Goodwood Grandstand—Preparing to Start; Epsom Grandstand— The winner of the Derby; Ascot Grandstand—The Coming In,* by R. G. Reeve after J. Pollard 1836. *The Bibury Club Welter Stakes,* by C. Turner R.A. after H. B. Chalon, 1801. (This coloured mezzotint depicts the first meeting of the Bibury Club at Burford Racecourse, Oxfordshire. The Prince Regent is among the spectators). *The Father of the Turf,* by John Jones after John Wootton—mezzotint.

Collectors of racing prints may care to be reminded of the Stevengraph silk pictures now coming back rapidly into vogue. Several depict well-known jockeys in different owner's colours, e.g. Fred Archer in Mr. Manton's red. Good condition and the original mounts are desirable.

Rowing
 Rowing at Oxford; The Start; The Race—lithographs after G. Howse,
 published by Ryman, 1859.

Shooting
 The return from Shooting, by Francesco Bartolozzi after Francis
 Wheatley R.A.—coloured stipple. (It is unusual for this engraver
 to be associated with this type of print since his chosen field was
 decorative and fancy subjects. Stipple is altogether an exceptional
 medium for sporting prints. One of the few of a semi-sporting
 nature is by Daniel Orme—*Evening, or the Post Boy's Return*, after
 George Morland). All the fine plates, after H. Alken, published by
 T. Marshall in 1820 under the title *The National Sports of Great
 Britain*, are of interest, as are the twenty oval sporting scenes of
 Orme's *Collection of British Field Sports 1807–8*, after designs by
 Samuel Howitt. Plates include: duck, hare, woodcock and pheasant
 shooting.

Swimming
 Children Bathing, by William Nutter after J. Russell, 1797—stipple.
 Bathing, by and after J. Pierson, *c.* 1800—stipple. *Boys Bathing*, by
 Edmund Scott after Morland—stipple.

Tennis
 J. E. Barre playing in the grand match on the Tennis Court, 1848, by
 William Bromley—line engraving.

Winter Sports
 Mer de Glace, by George Cruikshank after W.P., *1821*. *Boys Skating*,
 by Edmund Scott after Morland—stipple.
 The reader can amuse himself by adding fresh categories. The
bull-fight addict may look to Picassos' graphic work, but he will find
one plate in Orme's *Foreign Field Sports*, published in 1814 with a total

of one hundred plates. Similarly, the same publisher issued *Oriental Field Sports*, six years earlier, with aquatints by J. Clark.

COACHING PRINTS

These come close to sporting prints in popular favour and frequently the same artists were involved in both categories of print. It is not necessary to find any justification for this esteem. For the social historian, the coaching age was over; killed by the railway almost as soon as it got into full swing. These prints offer a charming reminder of that long-ago time.

A selection of fine aquatints follows. These delightful prints are after paintings by James Pollard unless otherwise stated. The would-be collector is again warned that prints in good condition are both costly and difficult to come across.

The Birmingham Tally Ho! Coaches passing the Crown at Holloway, by C. Bentley.

Scenes during the Great Snowstorm of December 1836: The Louth Mail; The Devenport Mail; The Liverpool Mail; The Birmingham Mail, by G. B. Campion—lithographs of 1837.

The Elephant and Castle on the Brighton Road, 1826, by Theodore Fielding.

Coaching Scenes, after W. J. Shayer—four plates, by John Harris.

Coaching Recollections; Changing Horses; All right; Pulling Up to Unskid; Waking Up; The Olden Time; The Night Team, by John Harris after J. Cooper Henderson.

The Stage Coach with the News of Peace, 1815; The Light Post Coach, 1817, by Robert Havell.

The Red Rover, Southampton Coach, by Charles Hunt.

The Mail Coach in a Fog, 1829; The Mail Coach by Moonlight; The Liverpool Umpire, by George Hunt.

Scenes on the Road—eighteen plates issued *c.* 1835.

The Roadsters' Album—sixteen plates issued *c.* 1845 (Fores), by C. B. Newhouse. Most loose plates by Newhouse usually come from

one of these scenes but there are odd plates like: *A Close Shave; A Lazy Housekeeper; A Disagreeable Time; Accidents Will Happen.*

Stage Coach Passengers at Breakfast 1819; Newman's Patent Stage Coach, 1822—by and after Pollard.

The Mail Coach behind time, after H. Walter; *A North East View of the New General Post Office, 1832*, by H. Pyall.

The Royal Mail departing from the General Post Office, 1830; The Mail Coach in a Drift of Snow, 1828; The Mail Coach in a Thunderstorm on Newmarket Heath, 1827, by R. G. Reeve.

West Country Mails at the Gloucester Coffee House; Royal Mails starting for the West from the Swan With Two Necks, by Christian Rosenberg.

The Mail Coach in a Flood, 1827, by Felix Rosenberg.

RAILWAY PRINTS

It's but a short step from coaches to "steam carriages", and the same artists were responsible for some of the finer early railway plates. Once again it is virtually impossible to do other than suggest a small selection. (Collectors who wish to specialise in this area should look out for the occasional exhibition of railway prints arranged in local museums and art galleries by the Curator of Historical Relics at the British Railways Board):

Victoria, The London Terminus of the Brighton and Dover Railroads, coloured line engraving by H. Adlard after T. Marchant.

London and Birmingham steam coach on a country road; The Progress of Steam, a view in Regent's Park 1831, by and after H. Alken.

Euston—Entrance Portico, Euston Grove Station; Slough Station, by and after J. C. Bourne—coloured lithographs.

Chirk Viaduct, Shrewsbury and Chester Railway—coloured lithograph, by G. Hawkins, after G. Pickering.

The Railway Station, by Francis Holl, after W. P. Frith R.A.—line engraving.

The Steam Omnibus "Enterprise", 1833, after W. Summers; *The London and Greenwich Railway*, by Charles Hunt, after A. Clayton.

The Liverpool and Manchester Railway, 1831; 'View of the Bridge on *the St. Helens and Runcorn Gap Railway,* by G. G. Hughes, after J. Shaw.

Four Views of a Train on the Liverpool and Manchester Railway, 1833, possibly by Hughes after Shaw.

The New Steam Carriage, after G. Morton; *The Liverpool and Manchester Railway,* seven plates after T. T. Bury, by H. Pyall.

The Engine and Train of the Birmingham and Liverpool Railroad, by Reeve and R. W. Smart, 1825, after S. Bourne.

North Midland Railway; Bridge over the Derwent; A View of the Bridge over the River Amber—pair of coloured lithographs, by S. Russell.

Later railway prints are too numerous to single out. In this category of print, a good clean impression is important and one is able to back one's own fancy from the considerable amount of choice available. Fine, early prints of the type listed are both scarce and expensive and undoubtedly a good investment. As an example, a serious collector willing to pay about £30 can look out for John Blackmore's engravings after J. W. Carmichael's *Views on the Newcastle and Carlisle Railway,* 1836. This includes twenty-three fine engraved plates.

NAVAL AND MILITARY PRINTS

Another category of print possessing considerable popularity. A number of tentative divisions are possible:

Battle Scenes
The Battle of the Nile, by W. Ellis after F. Chesham; *The Battle of the Nile,* by and after R. Dodd; *The Spanish Armada,* by J. Pine, after C. Lemprière; *The Battle of Marengo,* by L. Schiavonetti after Pelligrini—stipple; *The Battle of Waterloo,* by R. G. Reeves after W. Heath; *The Battle of Navarino,* by R. W. Smart after Sir J. T. Lee—etching; *The Eve of the Battle of Edgehill 1642,* by William Bromley; after Charles Landseer—line engraving 1852; *The Bombardment of Algiers,* by T. Sutherland, after Whitcombe; *The Battle of Alexandria,*

by A. Cardon after de Loutherbourg; *The Glorious Conquest of Seringa-patam*, by Vendramini after Porter—both stipple; *The Capture of the Two Top Sail Slave Schooner Bolodra on the 6th June 1829*, by E. Duncan; *The Battle off Cape St. Vincent*, by E. Bell after T. Luny—line engraving.

Costume Studies

The Highlanders, by Walker, after M. A. Hayes—lithograph; *The Highland Piper*, by C. Rosenberg, after Manskirch; Plates from Ackermann's *Costumes of the British Army*, most of which were engraved by John Harris after Henry Martens; Plates from *The Military Costume of Europe* published by T. Goddard in 1812; *The Royal British Bowmen at Erthig, Denbighshire*, by W. J. Bennett, after Townshend; *English Soldiers*, by F. D. Soiron after Bunbury—a series of seven plates, 1791—stipple, including a sergeant of infantry, a grenadier, a lifeguardsman and a drummer. *The Volunteer Corps of the City of London; The Volunteer Corps of the City of Westminster*, by M. Place, after Porter *c.* 1800—mezzotint.

Military and Naval Celebrities

Admiral Nelson, by Shipster after Rigaud—stipple; *Admiral Nelson*, by W. Barnard after L. F. Abbott (two prints exist—full length, half length)—mezzotint; *Admiral Lord Howe*, by and after Benjamin Killingbook—mezzotint; *Admiral Lord Rodney*, by P. W. Tomkins after Reynolds; *Admiral Earl Howe*, by D. Orme after Brown; *Admiral Lord Hawke*, by Bartolozzi after Coates; (the last three are all stipple engravings). *His Majesty George III reviewing the Dragoon Guards and the Light Dragoons*, by J. Ward after Sir W. Beechey—mezzotint; *The Army and the Navy, meeting of Wellington and Nelson*, by S. W. Reynolds after J. P. Knight; *The Duke of Wellington*, by S. Cousins after D. Lucas; *General Sir John Ligonier*, by J. Brooks after Latham—mezzotint; *Napoleon Bonaparte*, by W. Bromley, after Gérard—line engraving; *General Gordon*, by S. W. Cousins and T. L. Atkinson after Dickinson—mezzotint; *The Death of General*

Cathcart at the Battle of Inkerman, by W. Greatbach after R. Hind—line engraving; *The Duke of Wellington leaving the Horse Guards 1852*, otherwise called *The Last Return from Duty*, by J. Faed after J. W. Glass—mezzotint; *Nelson, Kneeling at Prayer*, by Frederick Bacon after T. G. Barker—line engraving. *The Death of Nelson*, by William Barnard—mezzotint.

Military and Naval Incidents

H.M. Brig Acorn, 16 Guns, in chase of the Piratical Slaver Gabriel, by T. G. Dutton, after N. M. Condy—lithograph; *View of the cutting out of the "Désirée", French Frigate of Forty Guns from Dunkirk Roads 1803*, by and after R. Dodd. *H.M.S. Galatea, among icebergs in the Southern Ocean, 1868*, by J. W. Day after O. W. Brierley—chromo-lithograph; *A View of the Landing of the New England Forces in the Expedition against Cape Breton, 1745*, by Brooks after F. Stevens; Plates from Orme's *Historical, Military and Naval Anecdotes*, 1819. *The Attack upon the Stockades near Rangoon*, by C. Hunt, after J. Moore. *The Dinner given to the Kentish Volunteers in the presence of their Majesties, 1800*, by and after William Alexander first Keeper of Prints at the British Museum. *The Retreat at Naseby; The Escape of William III at the Boyne*—mezzotint.

Naval vessels/military buildings

H.M.S. Maqueen, off the Start 26 January, 1832, by C. Rosenberg after W. J. Huggins. *H.M.S. Winchester*, by E. Duncan after W. J. Huggins. *H.M. Steam Frigate Geyser*, by C. Hunt after W. Knell. *H.M. War Steam Frigate Terrible*, by H. A. Papprill after W. Knell. *H.M.S. Cambrian*, by E. Duncan after N. Condy. *The Royal Dock-yards of Portsmouth, Plymouth, Chatham and Deptford*, 1789 (artist unknown). *Royal Military College, Sandhurst*, by W. J. Bennett after William Delamotte. *West point, from Phillipstown*, by and after W. J. Bennett. *Royal Artillery Barracks* and *Royal Military Academy, Woolwich*, by Thomas Fielding after G. F. Robson.

Romanticized militarism

Sailors Carousing, by W. Ward after J. C. Ibbetson. *The Sailors' Return* and *The Soldier's Return*, by W. Ward after Morland. *The Soldier's Return*, by W. Ward after F. Wheatley. *The Sailor's Orphans*, by W. Ward, after W. R. Bigg. *The Sailor's Farewell*, by J. R. Smith after Bunbury—all mezzotints. *The Sailor's Departure* and *The Sailor's Return*, by Bartolozzi after Benwell—stipple. *The Dead Soldier*, by J. Heath after R. Westall—line engraving. *The Soldier's Return* and *The Soldier's Farewell* by Henry Hudson after Ramberg—oval mezzotints 1785. Four stipple plates by George Keating after Morland 1791: *The Deserter; Trepanning a Recruit; The Recruit Deserted; The Deserter taking leave of his wife.*

Military caricature

Sixpence a day, 1775, attributed to J. Gillray. *A March to the Bank, 1787*, by Gillray. *Hero's recruiting at Kelsey's, or Guard Day at St. James, 1797*—hand-coloured etchings by Gillray. *Presbyterian Penance*, by T. Allen. *Reconnoitring; The Salute; The Guard*, by P. Rainger, 1907. *French Barracks* and *English Barracks*, by T. Malton after Rowlandson. *Military Caricatures*: five plates by H. W. Bunbury, including Recruits and *A Visit to the Camp.*

You will see from the above choice that the field is enormous and that most of the selections have been taken from the Napoleonic War period, as this is particularly well documented. Other periods, though, offer a comparable choice, and often at less cost.

TOPOGRAPHICAL VIEWS

Most collectors, when first thinking of getting together a small collection, turn instinctively to views and landscapes. If they were born in the country it is understandable that they are pleased to find a print of their native village, and if they can supplement this by a view of their old school, place of business or home district, so much the better. Printsellers are, accordingly, as accustomed to clients asking

77

for "any view of St. John's Wood or Hampstead", as they are for those who seek "prints with doctors or lawyers in them". Rarely is it possible, alas, to keep folios or drawers classified in such a way. The demand for topographical prints is strongest in the area they depict, so obviously it is cheaper, though more difficult, to find a Thameside view in the North of England rather than in London.

It is only possible here to suggest lines for an embryonic collection, choosing only fine plates by better known artists. The impressions are coloured aquatints unless otherwise stated.

The British Isles
London

Temple Bar, from the Strand; Hyde Park Corner—coloured lithographs from the fine set by T. S. Boys. *The Royal Exchange* by T. A. Prior after A. Thomas—coloured line engraving. *A View of Buckingham Palace from Green Park*, by W. Gauci, after T. Maisey 1836—coloured lithograph. *Billingsgate Market, 1851,* by G. Hawkins—coloured lithograph. *St. Paul's Churchyard c. 1835,* by Jules Arnout—coloured lithograph. *View from Kensington Gardens* by W. L. Walton after P. Brannan—from a set of coloured lithographs. *A View of Southwark Bridge; A View of Waterloo Bridge;*—by R. Havell & Sons. *The Promenade at Carlisle House*, by and after J. R. Smith—mezzotint. *The Encampment in Hyde Park, 1780,* by and after Paul Sandby. *View of Bloomsbury Square*, by Pollard and Jukes after Edward Dayes. *Fish Street Hill* and *Ludgate Hill*, by T. Morris after W. Marlow—line engraving. *Hackney, from the Downs*, by W. J. Bennett after W. Walker—1814.

Bath

Queen's Square; South Parade, by T. Gandon after T. Malton. Collectors interested in views of Bath would, of course, come much closer to modern times with the etchings of W. R. Sickert.

Brighton
The West Cliff, Brighton, by and after C. W. Wing *c.* 1830—coloured lithograph.

Edinburgh
The University, South Bridge Street; North Bridge Street; High School Wynd.

Glasgow
The Irongate, by S. D. Swarbreck 1837—coloured lithograph.

Gravesend
General View, after W. J. Huggins—early nineteenth century.

Halifax
A View of Halifax from the South East, by J. Horner—published by N. Whitley, Halifax 1822—coloured lithograph.

Leicester
The West Bridge with the Church of St. Mary de Castro—etching by William Ward 1872.

Manchester
Black Friar's Bridge, and *The late Dr. White's House, King Street*, by A. Aglio, after I. Ralston, 1823—coloured lithographs.

Newcastle on Tyne
Grainger Street, 1838, coloured lithograph by and after T. M. Richardson.

Oxford
High Street, after Griffith, by and after J. W. Edy *c.* 1800. *High Bridge, Oxford*, coloured lithograph after W. Westall, 1822. Views of Oxford by William Delamotte, Thomas Malton or Michael

Rooker are particularly fine. The latter issued 24 views of Oxford Colleges.

Salisbury
The Cathedral, and *The Burial House,* by F. Jukes, after E. Dayes, 1798.

Tonbridge
High Street, coloured lithograph by H. Harris, 1827.

Tunbridge Wells
Tunbridge Wells, from Frant, after J. J. Dodd by R. Havell.

Wales
Twenty-nine aquatinted views in Wales by and after Paul Sandby, 1775–1777. Executed in brown ink, this is the earliest set of aquatints produced.

Winchester
The Cross, coloured lithograph by L. Haghe after O. B. Carter *c.* 1840.

York
South East View, by R. Havell after Cave.

For collectors with an unlimited pocket, the following volumes represent the limit of the desirable. Even odd plates from copies that have been broken up are worth possessing. The artists used by the publishers to produce these coloured aquatints are all of the first category—men like Rosenberg, Stadler and Sutherland.

Ackermann:
Microcosm of London; History of Oxford, 1814; History of Cambridge, 1815; History of the Public Schools, 1816.

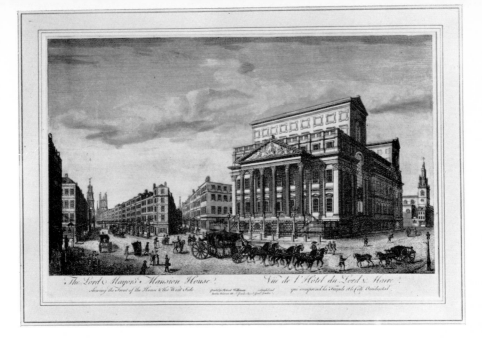

Above, "The Lord Mayor's Mansion House", 1770, line engraving (sub-sequently hand-coloured), artist unknown; *below*, "West Country Mails at the Gloucester Coffee House, Piccadilly", 1828, aquatint by Charles Rosenberg after James Pollard

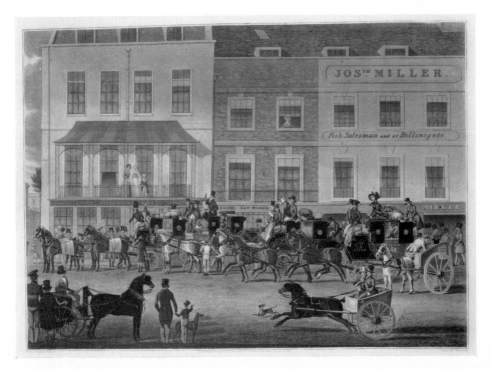

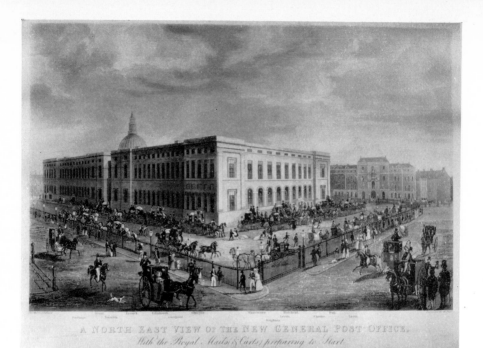

A NORTH EAST VIEW OF THE NEW GENERAL POST OFFICE,
With the Royal Mails & Carts preparing to Start

"The New General Post Office", 1832, engraving by H. Pyall after John Pollard; *below*, "The Library, etc., Merton College, Oxford", 1833, by John Le Keux after Frederick Mackenzie

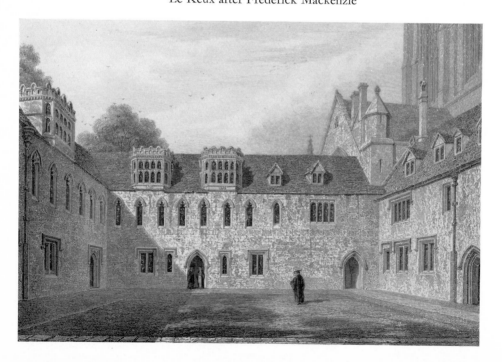

"The 4th Light Dragoons", aquatint by John Harris
after Henry Marten

Above, "Capture of the U.S. frigate *President* by H.M. frigate *Endymion*", 1815, coloured aquatint by John Hill after an unknown naval officer; *below*, "Surrender of Lord Cornwallis at Yorktown", 1781, lithograph by Nathaniel Currier after John Trumbull

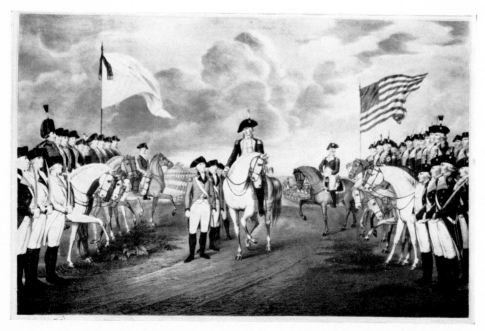

Thomas & William Daniell:
Picturesque Voyage around Great Britain 1814–1852—8 volumes.

Thomas Malton:
Views of the Colleges in Oxford (24 plates); *Views of the Cities of London and Westminster* (100 plates); *Views of the City of Dublin*, by James Malton, after Thomas Malton (26 plates.)

All engravings, in good condition, by the better known eighteenth-century topographical artists are likely to be expensive. The poor collector is driven to the lesser men. Thomas Bowles, for instance, was a prolific line engraver of London views. His engravings are frequently met, "improved" by subsequent hand colouring. Examples include: *Grosvenor Square, 1794; Royal Exchange; Leicester Square, 1752.*

J. B. Allen is another of these less well-known line engravers. He seems to have specialized in London bridges after paintings by Samuel Scott, and then there are the men who worked after Turner— W. B. Cooke in *Southern Coast*, 1814–26; or R. Brandard and W. Radclyffe, members of the so-called "Birmingham group" who engraved the illustrations for *Rivers of France* 1837 and *Picturesque Views in England and Wales*, 1838.

For the collector who must have stiff, accurate topography at all costs, the line engravings of William Woollett are perhaps the most classic of all. His best work was romantic landscape after Claude and Richard Wilson, but there exist also: *A View near Henstead in Suffolk, Pain's Hill, near Cobham, Walton Bridge in the grounds of Sir Francis Dashwood, West Wycombe and three other views of the same locality.*

A collector prepared to accept later less formal work might consider the mezzotints of David Lucas, after Constable, or the fine etchings of Sir Francis Seymour Haden which are now coming back into favour after years of neglect. Haden loved the river and in particular the Thames, hence the titles of prints like *Egham Lock, Kew Side, The Water Meadow* and *On the Test*. Many critics consider Whistlers' graphic work among the finest for views of London and the river.

Views other than in the British Isles

Regardless of "state" and "condition", these prints always find a ready buyer. Most modest collectors will not possess a pocket deep enough to purchase them but it's as well to be able to recognize representative specimens when you come across them.

AMERICANA

Early American views are sought after as remorselessly as etchings by fine American artists like Whistler and Mary Cassatt. (Aquatints unless otherwise stated):

Joseph F. W. des Barres
The Atlantic Neptune, containing aquatinted views of Louisburg, Boston, etc.

William James Bennett, 1787–*c.* 1830.
New York Views: *The Bay near Bedloe's Island,* after J. G. Chapman 1836. *The New York Quarantine, Staten Island,* by and after Bennett 1833. *Brisk Gale, Bay of New York,* by and after Bennett 1839. *Great Fire; Ruins of the Great Fire,* after N. Calyot 1835. *New Orleans;* view by and after Bennett. *Baltimore; View from Federal Hill,* by and after Bennett *c.* 1820. *Buffalo: The Milwaukee passing Buffalo Lighthouse,* after J. C. Miller. *Charlestown, View,* after Cook. *Washington: The City from beyond the Navy Yard,* after G. Cook, published by L. Oliver 1834. *West Point: A view from Phillipstown,* by and after Bennett.

Pierre Charles Canot *c.* 1710–1777
Of French birth, he is said to have died in London. All his engravings are in line. *New York; South-east view of the City* and *South-west view of the City,* after Captain T. Howdell. *Charlestown; A general view. Louisburg: A view from the lighthouse when the city was besieged in 1758,* after Captain Ince 1762. *Montreal: A view from the*

East, after Patten. *Quebec: View from the Basin*, after F. Swain. *View of the Landing Place, above Quebec*, after Captain H. Smythe.

Juste Chevillet 1729–1790—a line engraver.
General Green of the American Army, after Peale: *Death of General Montcalm at Quebec*, after de Lille.

Nathanial Currier 1813–1888—a lithographer and publisher.
All his plates are lithographs. *Surrender of Lord Cornwallis at York-town, 1781*, after John Trumbull, *New York, from Brooklyn Heights* and *New York, from Weehawken, North River*, after F. Palmer. *New York Yacht Club Regatta*, after C. Parsons. *The Scenery of the Hudson River*, after F. Palmer. *The Yacht America*, after W. J. Romer.

Thomas G. Dutton—a lithographer, mostly of ships, working in London in the mid-nineteenth century.
The Yacht America, after O. W. Brierley. *The Anglo-American Yacht Race round the Isle of Wight, 1868. The Anglo-American Yacht Race, 1870*, after R. L. Stopford. *The Anglo-American Yacht Race, 1870. Start of the Yachts Dauntless and Cambria; Cambria in mid-ocean*, by and after Dutton. *The New York Club Yacht North Star*, published by Ackermann in 1853. *The New York and London Packet Ships: Southampton; Victoria* 1860. *British and North American Royal Mail Steamships: Arabia* and *Asia. The U.S. Frigate St. Lawrence, off Osborne, Isle of Wight*.

John William Edy
He was born in Denmark in 1760, and he appears to have been working as late as 1820. *Six North American views*, after G. B. Fisher, *1795; Cape Diamond; The Plains of Abraham and part of the town of Quebec; St. Anthony's Nose; On the North River; The Province of New York; The Falls of Montmorency and Chandière.*

Endicott & Co., publishers *c.* 1840.
American Mail Steamboats—a series of ten large lithographs.

John Hill
He worked for Ackermann in London before emigrating to America where he died *c.* 1825. *A portfolio of eighteen coloured aquatints*, after W. G. Wall, known as *The Hudson River Portfolio*—*Broadway, New York*, after T. Homer.

Joseph Pennell 1858–1926
New York—*Palisades and Palaces, Oil Works;* and *Fifth Avenue*, —etchings.

F. Perret
Paul Jones attacking the English Fleet under Admiral Pearson; The Engagement between the Quebec and the Surveillante—coloured lithographs by and after Perret.

Thomas Ryder *c.* 1745–*c.* 1810
The Politician (Dr. Benjamin Franklin) after S. Elmer, stipple.

Edward Savage—a line engraver who was born at Princetown in 1761. He died in the same town in 1817.
Benjamin Franklin, after D. Martin. *George Washington.*

Francesco Scacki (publisher).
A correct view of the Battle near the City of New Orleans on 8 January 1815.

Samuel Seymour—an American artist of small output working between *c.* 1800 and 1820.
The Naval Engagement depicting an incident of the War of 1812—the taking of H.M. Sloop Frolic by the U.S. Sloop Wasp, after J. J. Barralet.

B. Turner

Born in New York 1775, he died seventy-three years later in Baltimore. Many of his subjects are portraits, e.g. *Benjamin Franklin; John Quincy Adams.*

George Washington

Portraits of Washington are so much in vogue that they are grouped together. *General Washington*, published by Carrington Bowles after Le Mire—mezzotint; by Philip Dawe, after R. Wright—mezzotint; by Valentine Green, after C. W. Peale—mezzotint; by William Nutter, after G. Stuart—stipple; by E. Savage—line engraving; by B. Tanner; *The Washington Family at Mount Vernon*, by and after E. Savage.

Other parts of the world for which fine prints have been executed include:

India

Thomas and William Daniell—*Oriental Scenery or views of Hindustan,* 1795–1805. This volume contains 144 exquisite aquatints coloured in imitation of water colour drawings and mounted. John William Edy—*Twelve Views of the Kingdom of Mysore,* 1794.

Norway

John William Edy—*Picturesque Scenes of Norway*, published by Boydell and containing 80 plates.

France

Views in the South of France, chiefly on the Rhone, engraved in line by George Cooke and J. C. Allen from drawings by P. de Wint, after original sketches by John Hughes of Oriel College, Oxford, published by Leggatt 1830. *Paris and its Environs Displayed in a series of Picturesque Views* 1830—drawings by A. C. Pugin, line engravings by Charles Heath—2 volumes—Jennings and Chaplin, Cheapside.

More sought after French items are the lithographs of T. S. Boys or Richard Bonington and aquatints after S. Prout, or there are twenty picturesque views of Paris stated to have been etched by Thomas Girtin and aquatinted by other hands, which were published in 1803.

A charming series is *Travelling in France*, a series of fine aquatints by J. C. Stadler and F. C. Lewis after F. G. Byron, published in 1802. Even the sporting artist, R. Havell, has at least one French view to his credit, a coloured aquatint after Chapuy, of the town and harbour of Marseilles, issued in 1838. Good nineteenth-century French lithographers include Jules Arnout, Jacottet, Chapuy and Muller. For a more romantic approach, some of the provincial scenes of Eugene Isabey, especially of the Massif Central, are delightful.

Throughout Italy, Greece, Germany, the Low Countries and the Mid-East, the British nineteenth-century artists, amateur as well as professional, strode on and left their impressions in print. Edward Lear, David Roberts, John Frederick Lewis, James Duffield Harding and the Richardsons are among the better known. One of the charms of this area of collecting is the pleasure of coming across a more modest forgotten print by some little known amateur whose work from the standpoint of the researcher may be just as interesting as that of the greater men. Most print shops will be able to provide a reasonable cross-section.

5
What to Collect Today

The basic rule in print collecting is to make haste slowly. At first, the beginner is bound to acquire prints which later on he will wish to discard. The act of acquisition, if not too expensive, affords at the very least useful instruction. It requires self-discipline, though, to confine one's attention to a small area of print collecting, but if one can only summon up the will-power to resist temptation, a shapeless assortment of miscellaneous and largely useless prints will be avoided.

On the whole, the beginner should put himself in the hands of the most reputable dealers and buy the best example of a particular print that he can afford. Above all, doubtful "bargains" in street markets and general antique "fayres" should be avoided. If he wants a Sickert etching of Dieppe or Bath or Mornington Crescent, for instance, the price should be around £25–£30 for a good example; if he's offered one for £5 his precious bargain probably won't be all that it seems.

There are a number of possible categories open to the beginner: aquatint views of a particular area; fancy subjects in stipple; sporting subjects. These are obvious and have already been discussed, so that it will repay him if he takes a little time to decide his field of interest for himself. If the print-collector is wise to specialize, he should do so in the whole field of his choice. Supposing this to be "England in the 1830s", then his aquatint after Alken or Pollard is set off better by Adam candlesticks, be they solid silver or antique Sheffield Plate. It will be all the more pleasing if an early Copeland plate with a hand-coloured picture by David Lucas complements the line engraving of William IV, all of which means that the print collector has to be a bit of a research student into the social history of the period of his choice.

As a result of his hobby he can hardly avoid both improving his sense of aesthetic discrimination as well as obtaining a sound grasp of the prints he admires.

A number of categories lend themselves to this kind of treatment, but there are pitfalls; even when the collector is able to make a list of the prints he is looking for he may live fifty years and never see some of them. They can well be lacking from the major public collections. It is at this stage that he realizes that part of the enjoyment of print collecting lies in the thrill that comes from meeting the unexpected or long-awaited at the most improbable moment and place. Should he feel the rewards are meagre then it's to be hoped he'll take courage and persist. The absence of "thematic" print collections is one of our national tragedies. They are always of interest when they come up in the sales-room so that even the mercenary should find a goad for his endeavours.

Here are some suggestions for forming a collection relating to one's profession:

SCHOOL SCENES

The Village Schoolmistress, by and after Edward Harding, oval *c.* 1790, line engraving and exists printed on satin; *The Village Schoolmistress*, by William Barnard after Page, 1808; *The Village School Dinner in the Garden*, by William Barnard after W. R. Bigg, 1808—both in mezzotint; *A Schoolmaster and his Scholars*, by George Clint after Gerard Dou—mezzotint; *The Poor Teacher*, by W. Geller, after Richard Redgrave—line engraving; *A Boy's School; A Girl's School*, by George Keating after Pasquilini 1788—mezzotint; *Going to School* and *Coming from School; The Scholar Rewarded* and *The Dunce Disgraced*, both pairs by Charles Knight after T. Stothard R.A., ovals—stipple; *The Boys' School; The Girls' School*, by John Faber the Younger, after Mercier—mezzotint; *The Village School in Repose*, by J. P. Quilley, after Henry Richter—mezzotint; *The Village School in an Uproar*, by C. Turner 1825, after Richter—mezzotint; *Schoolboys (The Masters Gawler)*, by J. R. Smith after Reynolds—mezzotint; *Schoolboys giving*

money to a blind man, by J. R. Smith after W. R. Bigg—mezzotint 1781; *Going to School, The Return from School*, by C. Turner after Maria Spilsbury—mezzotint; *The Schoolmasters*, by James Ward R.A. after William Owen—mezzotint; *The Truants*, by William Ward, after W. R. Bigg—mezzotint; *A Visit to the Boarding School*, by William Ward after Morland—mezzotint; *The Rev. John Russell, Headmaster of the Charterhouse*, by William Say, after B. R. Faulkner—mezzotint; *The School Door*, by George Keating after Francis Wheatley—mezzotint.

THE THEATRE

An actor or keen theatregoer can get together a pleasant assembly of stage plates. These tend to fall into two groups—actors and actresses, and scenes from plays, mostly by Shakespeare and usually from the edition produced by Boydell. In the first category are: *John Philip Kemble as Hamlet*, by William Barnard—mezzotint; *Mr. Kemble as Coriolanus*, by Robert Meadows after Lawrence—stipple; *Mrs. Siddons as the Tragic Muse*, by William Burnley after Reynolds —mezzotint; *Mrs. Siddons*, by Bartolozzi after Downman—stipple; *Mrs. Siddons as Zara in The Mourning Bride* by J. R. Smith after Lawrence—mezzotint; *Mrs. Hartley as Andromache in The Distrest Mother* —oval, 1782, by J. K. Sherwin—stipple; *Kitty Clive the Actress as Philida*, by John Faber the Younger after Peter van Bleeck— mezzotint; *Peg Woffington as Mrs. Ford in The Merry Wives of Windsor*, by John Faber the Younger—mezzotint; *Charles Keene as Macbeth*, by Richard J. Lane after A. E. Chalon—lithograph; *David Garrick as Richard III, 1772; as Abel Drugger in The Alchemist*, 1776, after Zoffany—mezzotints by J. Dean; as Hamlet; as King Lear, by McArdell, after B. Wilson—mezzotints; as Richard III, by Charles Spooner after Hogarth—mezzotint; William Penkethman, as Dan Lewis in *The Fop's Fortune*, by Edward Harding, after Vertue—stipple—1794.

In the second category, scenes from plays, there occurs a greater breadth of choice which might include: Cordelia, King Lear, The Taming of the Shrew, by Bartolozzi, after Angelica Kauffmann—

stipple; Falstaff escaping from Ford's House, by John Chapman, after Bunbury, 1792—etching; Beatrice in *Much Ado about Nothing*; Perdita in *A Winter's Tale*, by T. Cheesman after R. Westall—stipple; *Shylock and Jessica*, by G. T. Doo, after G. S. Newton, 1833—line engraving; *The Witches and the Cauldron*, after Reynolds; *The Boar's Head Tavern*, after R. Smirke, by Robert Thew—stipple.

A useful volume of Shakespearean Scenes is "A Series of Engravings by Heath and Bartolozzi from paintings by Stothard, Fuseli and Hamilton", published by Howlett and Brimmer in 1818. This is especially interesting for the engravings after Henry Fuseli, the Swiss R.A., whose *outré* works are very much to contemporary taste. Another, rarer, book is *Shakespearian Tableaux*, printed by Paul Jerrard with twelve handsome chromolithographs of scenes from the plays. A "Drawing-room" book, it dates from the 1840s.

Equally charming to this collector will be views of theatre exteriors, like *The King's Theatre, Haymarket*, by B. Howlett after Schnebbelie, 1821, or: *The New Theatre Royal, Haymarket*, by Dodd after Schnebbelie, 1822, both line engravings.

Occasionally there may be an interior scene, as with the fine Sickert etchings of the old Bedford Theatre or Rowlandson's *Opera Boxes* or *Box Office Loungers* after Wigstead.

One might be neither schoolmaster nor theatregoer, but in these islands we are all subjects of the Crown and a loyal collection of prints might be considered:

ROYALTY

This group will provide a collection of fine prints to be reckoned with not merely on grounds of loyalty but because it includes finely executed prints by some of the best known engravers.

Starting in the seventeenth century, the early portraits of Charles I and Charles II after Van Dyck tend to be stiff and rather dull. Isaac Beckett's mezzotint of William III, like that of George I by John Faber the Younger, is over-formal. There is a little improvement with

R. Sayers' coloured line engraving after Canaletto—*George II going to the House of Lords*—but it is from the time of his successor, George III onwards, that the collector has full freedom of choice, ranging from the official portrait to the outright condemnatory:

George III

Formal engravings after J. S. Copley: W. Hamilton 1790, G. B. Cipriani—stipple; *Returning from hunting*, by M. Dubourg after Pollard —mezzotint, published 1820; *George III, Queen Charlotte and family*, by R. Earlom after J. Zoffany—mezzotint; *Temperance enjoying a Frugal Meal*, 1792; *A Connoisseur examining a Cooper*, 1792 by Gillray—etchings.

George IV

In his travelling carriage, published by G. Humphrey *c.* 1825—aquatint; *When Prince of Wales, as an Archer*, by Bartolozzi after J. Russell R.A.—stipple; *H.R.H. The Prince Regent driving Miss Q* (Harriet Wilson, a famous Brighton Beauty), by W. Blake—stipple; *Travelling in Hyde Park*, by M. Dubourg, after Pollard—aquatint; *In his Robes*, by Edward Scriven after F. D. Stephanoff—stipple; *A Voluptuary under the Horrors of Digestion 1792*; *The Morning after Marriage*, 1788, by Gillray—etchings.

William IV

In his Coronation Robes, by J. Alais—stipple; *As a Midshipman on board H.M.S. "Prince George"*, 1780, by Valentine Green—mezzotint; *Official Portrait*, after Lawrence by F. C. Lewis—mezzotint; *William IV and the Butcher Boy, or The Impudent Challenge*, by H. Heath after Pollard —line engraving.

Queen Victoria

Queen Victoria opening the Great Exhibition, by Samuel Bellin after H. C. Selous, 1856—line engraving; *Queen Victoria*, by George Baxter: Large-stamped mount, De La Rue's edition—Penny Pocket Book;

The Coronation of Queen Victoria; *The Opening of Queen Victoria's First Parliament*, 1838, by George Baxter.

Edward VII
State Portrait, by J. B. Pratt, after Luke Fildes—mezzotint.

Scottish Nationalists may be interested in the following plates: *Alexander III, King of Scotland, rescued from the Fury of a Stag, by the Intrepidity of Colin Fitzgerald*, by Bartolozzi, after B. West 1788— stipple; *Mary, Queen of Scots; The Departure to France; The Flight into England*, by Bartolozzi, after R. Westall 1779; *The Old Pretender*, after De Troy, *The Young Pretender—after David*, by Gérard Edelinck—line engravings.

Republicans will be joyful to see: *Cromwell, refusing the Crown of England*, by Samuel Bellin, after H. Maguire, or *Oliver Cromwell*, by Bartolozzi after R. Waiker, 1802.

During the late eighteenth and early nineteenth centuries, a romantic interest was awakened in early British history. The inspiration wasn't terribly stimulating but those who like this sort of thing can look out for: *The Burial of Harold*, by F. Bacon, after F. R. Pickersgill, published by the Art Union in 1851—line engraving; *Henry VIII's First Meeting with Anne Boleyn*, by J. S. Agar, after T. Uwins 1819— stipple; *Caxton showing the first specimen of his printing to Edward IV*, by Frederick Burnley after D. Maclise.

So far, suggestions have been made for the print collector by categories of subject. Other possibilities also exist, and these are at a higher level, according to differences of technique.

"Glass" Pictures

This is an unusual offshoot of mezzotint engraving. Discriminating collectors have long found a charm in this curious branch of engraving, but until quite recently prices had not increased anything like as much as in other branches of the fine arts. In the last year or so there has been a renewed interest and an appropriate rise in prices.

The technique of making a glass picture evolved alongside that of the mezzotint engraver. John Smith, not to be confused with the later and better known John Raphael Smith, appears to have been the first to produce glass pictures, or "transfer engravings behind glass". The method used, as described in a manual of 1700, was to steep the print to be transferred in warm water and to lay it on the glass by degrees. After drying, a coat of turpentine varnish was applied and, on drying again, the print was ready for painting on—the colour of a "swarthy complexion" or a "human body". The result is rich and oily, and in the eighteenth century, ignorant of our modern colour processes, it is easy to understand the popularity of these glass pictures.

Among artists who worked in this way were J. Simon, who engraved subjects of a romantic nature after Watteau, Boucher and Lancret; James McArdell who worked principally after Reynolds; Richard Houston who also engraved portraits; and Richard Purcell who adopted a pseudonym—"C. Corbutt". Apparently some discrimination is needed in buying his mezzotints for he is stated to have worked as a copyist for the publisher Sayer of Fleet Street. This stricture, however, does not apply to the portraits he chose to "paint in" on the glass.

Clearly, as regards subject matter, portraits of Royalty and the famous men and women of the age are frequently met with. Two popular portraits were of the Duchess of Hamilton and the Countess of Coventry, two Irish sisters who were noted beauties. The Duchess died young, alleged to have been poisoned by a beauty product used to whiten the skin.

Nowadays, we have the popular illustrated press to bring to us similar pictures, so it is not always easy for us to understand the vogue for portraits in the late eighteenth century. This also explains why such prints are often less expensive than other more popular categories, like sporting prints which were also reproduced on glass.

A collector who wants to bring a gracious touch of the eighteenth century into his home could select any of the following prints—all mezzotints: *Elizabeth, Duchess of Hamilton*, by James McArdell after

Cotes; The same, by and after Richard Houston; The same, by John Faber the Younger after Hamilton; *Maria, Countess of Coventry,* by Richard Houston after Liotard; The same, by Richard Houston after Cotes; *The Fair Nun Unmasked,* by Richard Houston after Henry Morland; *Correspondence,* by C. Corbutt (Richard Purcell) after Philip Mercier; *Domestick Amusement,* Playing on the Guitar, by James Watson after Philip Mercier; *The Lute Player,* by John Faber the Younger, after Franz Hals; *Mary, Duchess of Ancaster,* by Charles Spooner after Reynolds; *The Peach Girl,* by James Wilson after Rosalba; *The Suspicious Husband,* by James Wilson after Martin.

There is another process, akin to that of the glass picture, of which one hears little today—"transparency". This was discovered, apparently accidentally, by Edward Orme in the early 1800s. If a print is painted on both sides with a mixture of mastic and turpentine and framed between two pieces of glass, it can be illuminated from the back by a small light. Prints with dark masses of shadow can be very effective if so treated. Orme's own coaching print after Morland, the stipple *Evening, or the Post-Boys' Return,* is a good example.

JAPANESE COLOUR PRINTS

This is a more exotic suggestion for the print collector still without his chosen speciality to consider. Immediately after the war such items were, understandably, completely out of favour and it was possible to acquire fine prints at low prices. Indeed, until the early 1960s, such prints attracted little interest in the sales-rooms. From 1964 onwards, however, prices have spiralled upwards rapidly. An exhibition was held of Japanese prints, mostly by Harunobi, by the British Museum in 1964, and, as is so often the case, this sparked off a general revival of public interest. How far things have changed will be realized when one recalls that fine Japanese prints sold for about £30 in the 1950s.

The beginner to Japanese prints finds himself faced with many artists, all of whom seem to possess bewildering names so that even within this special field it is probably wise to specialize still further.

Japanese prints of the eighteenth century, for instance, often depict courtesans and actors and were considered "low-life" prints by the Japanese themselves. Such prints are not intended to be great art but are rather like today's coloured pin-up girls. Nevertheless, such a grouping could include works by Utamaro, Sharaku and Utagawa Kunimasa, who are among the great names of Japanese art. Not everyone will want Oriental theatre prints but few will resist the charm of *Chuban*, by Harunobi. A youth is feeding a pet rat he is holding in his hand. He is watched by a lovely maidservant, happy to find an excuse to interrupt her dusting, nibbling the handle of her mop. At the top of the print is a poem: "How auspiciously the shadow of the pine tree appears on the shoji I am dusting".

Japanese prints had an enormous influence on late nineteenth-century artists, especially Whistler and Toulouse-Lautrec. Collectors wishing to explore this field further are recommended to read Mr. J. R. Hillier's *The Japanese Print* (George Bell 1960), in view of the very specialized nature of the medium.

THE DAEMONIC

Under this heading I group my own personal recommendation for the thematic print-collector of the 1970s. One reason for my choice is that it affords a pretext to look for the prints after two misunderstood and eccentric artists, Henry Fuseli and John Martin.

Taking the latter first, both mezzotints and line engravings have been produced after Martin's grandiose works. The engravings in line will almost certainly be by Charles Mottram and meet little demand. Mottram was a workmanlike rather than brilliant artist but it is instructive to acquire one of his impressions, an India paper proof, if possible, in order to compare it with Martin's own freer conception. Martin's vision is exemplified in the following prints: *Belshazzar's Feast; Joshua Commanding the Sun to stand still; The Deluge; The Fall of Nineveh; The Death of the First-born; Pandemonium; Satan in Council; The Eve of the Deluge.*

It may well be that these fine engravings will be appreciated shortly in a sudden surge of public favour, as happened to Samuel Palmer and Edward Calvert. Martin, after all, stands in the same line of descent from Blake.

Fuseli requires to be placed on a different footing. A Swiss who published a critical study devoted to engraving at Zurich in 1771, he came to this country and became English by adoption. His attempts to translate his theories into an art form were not always to the public's liking. Like Blake, he sought to illustrate Milton's *Paradise Lost*, almost as difficult a proposition as setting *Hamlet* to music. His strange hates and strong language, together with his strict martinet-like discipline while Professor of Painting and, subsequently, Keeper at the Royal Academy, hardly endeared him to his fellow men. According to Benjamin Haydon, who was one of his pupils, Fuseli was the "most grotesque monster of literature, art, scepticism, indelicacy, profanity and kindness". Readers will note the word "grotesque". His paintings of scenes after Shakespeare and Milton reveal this very clearly. There are two magnificent stipple engravings by J. Heath after Fuseli's *Macbeth* which come from a volume published by McLean in 1818. The full title, should you come across it, is *A Series of Engravings by Heath and Bartolozzi, from paintings by Stothard and Fuseli to illustrate the works of Shakespeare and Milton*. Fuseli's contribution is *The three generals meeting the Witches* and "*I have done the deed*".

An edition of *Paradise Lost*, published by Vernor, Hull and Sharpe, of Poultry, London, 1808, contains stipple engravings after Fuseli by W. Bromley, A. Smith and James Neagle. These are interesting but lack the intensity of the Shakespearean scenes. Fuseli was drawn, not surprisingly, to the Ancients, and his *Death of Oedipus*, a colour mezzotint by William Ward, is very handsome.

Collectors at a loss for a suitable theme can always ask their print dealer for advice. Christopher Mendez came up recently with *Portraits of Artists* which provided the enterprising collector with a fascinating opportunity to obtain the nucleus of a thematic collection at remarkably low cost.

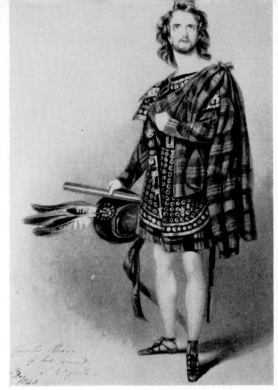

Charles Keane as Macbeth, a litho-
graph by Richard Lane after A. E.
Chalon

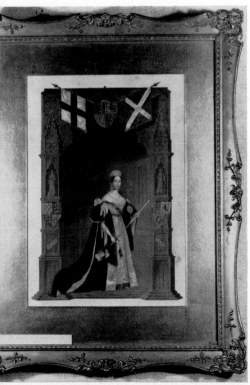

A George Baxter colour print of
Queen Victoria

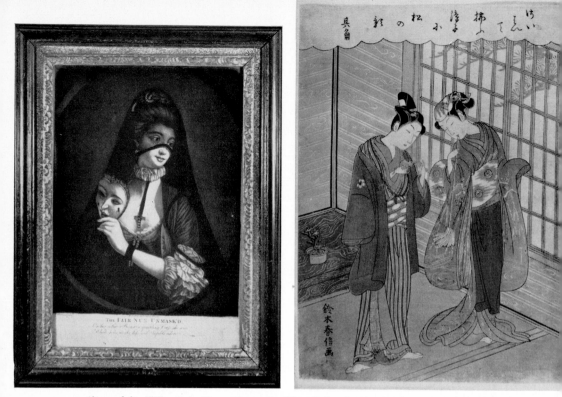

Above, *left*, "The Fair Nun Unmasked", a "glass" picture by Richard Houston after Henry Morland; *right*, "Chuban", colour print by Harunobi, *below*, "Covent Garden Flower Market, 1967", blockprint and lithograph by Edward Bawden

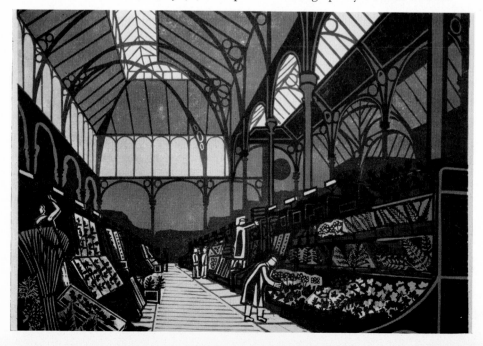

6

Some Practical Help for the Print Collector

THE PUBLIC COLLECTIONS

One of the finest and cheapest ways to become master of one's subject is to read about it at length. This country has an excellent public library system and most of the volumes contained in the book list at the end of this volume can be read at home in comfort. An even better method is to see for yourself by visiting the great national collections of prints. This puts collectors living in London at a considerable advantage because the British Museum and the Victoria and Albert Museum are on their doorstep. The really keen collector will obtain from the Keeper of Prints at the British Museum the little blue card which entitles him to be a regular visitor to the Print Room, but even the casual visitor may be admitted on application. Such visits will bring the incidental benefits of seeing prints properly mounted and kept in solander boxes. Books of reference, some of them rare, are to hand and the staff is able to answer nearly all questions put to them.

Most of the English public collections contain a print section and some of the more worth while prints are to be seen at:

Birmingham—The City Art Gallery; Cambridge—Fitzwilliam Museum (a rare collection of eighteenth-century coloured engravings); Cardiff —National Museum of Wales; Leicester—Museum and Art Gallery; Liverpool—Walker Art Gallery; Manchester—The City Art Gallery, Whitworth Art Gallery; Norwich—Castle Museum; Nottingham—

City Museum and Art Gallery; Oxford—Ashmolean Museum, Bodleian Library; Sheffield—The Graves Art Gallery.

For those able to travel outside this country, opportunity should be taken to visit any of the following museums with particularly fine print collections.

Amsterdam—Rijksmuseum; Berlin—Kupferstichkabinett; Buffalo—Fine Arts Academy, Allbright Art Gallery; Cambridge; Mass.—Harvard College; Florence—Uffizi Galleries; Hamburg—Kunsthalle; Lyons-Bibliothèque du Palais des Arts; Madrid—Biblioteca Nacional; Minneapolis—Institute of Art; Munich—Alte Pirakotek; Nantes—Musée Dobrée; Nuremburg—Germanisches Museum; New York—Public Library; Paris—Bibliothèque Nationale, Louvre; Rome—Galleria Nazionale; Rotterdam—Boymans Van Beuningem Museum; Vienna—Hofbibliotek; Washington—Library of Congress; Zurich—Kunsthaus.

There are also some private collections in historic houses and stately homes. Details can be found in: *Historic Houses, Castles and Gardens in Great Britain and Ireland* and *Museums and Gardens in Great Britain and Ireland* (Index Publications). The National Trust owns and maintains many places containing items of interest to the print collector. Its address is 23 Caxton Street, London, S.W.1.

The risk of theft has increased so much nowadays that many owners are understandably chary of publicizing their ownership of fine prints or fine anything else.

DEALERS

Many beginners tend to be suspicious of dealers, but no reputable dealer ever takes advantage of his relationship with a client, because he is hardly likely to improve the reputation and status of his business by so doing.

Notice the words "reputable dealer". These are important, and it

is probably best for the beginner to confide his wants and range of interests to the dealer of his choice and be guided by his opinion. Once again, many of the best specialist print sellers are in London, but the collector should not feel that because a dealer has a West End address all his customers are American oil magnates and that his small purchase will be of no interest.

Generally, the standards both of advertising and selling prints, as with other categories of antiques, have improved recently. The "Misrepresentation Act" has forced the leading auctioneers and dealers to redraft their conditions of sale. The British Antique Dealers Association will take up the matter with the dealer concerned if the buyer feels he has been misled. This of course, applies only to members of the Association, so it may be worth while looking out for their sign in a shop window.

The newly-opened Antique Hypermarket in High Street, Kensington, contains a few printsellers and the management has stated that either the exhibitor or the management itself will refund the purchase price if the buyer has been misled or sold other than what he contracted to purchase.

The following dealers all have premises in Central London and are particularly well known: Arthur Ackermann Ltd., 3 Old Bond Street, W.1; The Agnew Gallery, 43 Old Bond Street, W.1; The Alecto Gallery, 38 Albemarle Street, W.1; P. & D. Colnaghi Ltd., 14 Old Bond Street, W.1; Craddock & Barnard, 32 Museum Street, W.C.1; Frederick B. Daniell & Son, 32 Cranbourn Street, W.C.2; Folio Fine Art Ltd., 6 Stratford Place, W.1; Messrs. Lumley Cazalet, 24 Davies Street, W.1; Marlborough Fine Art Ltd., 39 Old Bond Street, W.1; Christopher Mendez, 32 Great Queen Street, W.C.1; The Parker Gallery, 7 Albemarle Street, W.1; William Weston, 10 Albemarle Street, W.1; Weinreb & Douwma Ltd., 92 Great Russell Street, W.C.1. Outside London, you will be welcome at: The Boar Lane Gallery, Sanders of Oxford Ltd., The Oxford Gallery, all in Oxford; The Hambledon Gallery, Blandford, Dorset; The Stone Gallery, Newcastle-upon-Tyne; The Tib Lane Gallery, Manchester.

Collectors looking for really complete and detailed lists of print-sellers should consult the *Guide Emer*, published every two years by Les Éditions Emer, 118–120 rue de Rivoli, Paris 1er. This contains over 40,000 names and addresses including printsellers, antiquarian booksellers and useful people like exporters and packers.

The guide is classified by countries, cities and even streets where this is warranted, in addition to specialized categories. In England, the guide can be obtained from: G. & F. Gillingham Ltd., 4 Crediton Hill, London N.W.6.

Even the bed-ridden or invalid collector need not despair; there are several dealers who specialize in the postal trade. Two such are: Richard A. Nicholson, 17 Chester Road East, Shotton, Chester, and P. J. Radford, Denmead, Portsmouth.

THE SALE-ROOM

Sooner or later the print collector is bound to be tempted into the sale-room and there is little doubt that provided he keeps his facts straight and his eyes open he will be the beneficiary for so doing. For those collectors who are also investors, hedging against inflation, and who regard the Times-Sotheby Index with the same reverence as the back pages of the *Financial Times*, there are some hazards. What creates the firm market in old masters or is responsible for the weak performance of mezzotints? The criteria are desperately unreliable—aesthetic impulses and the ups and downs of the inflationary spiral perhaps. The buyer of Rembrandt's *Large Lion Hunt* for £2,300 at Parke-Beret's New York sale-room in 1967 will probably earn no immediate profit from his purchase. He is doubtless aware that the same print sold for 13 guineas thirty years ago and that it will certainly appreciate in value over the next few years. As the end of each auction season arrives, so the fine arts auctioneers report new records and staggering price increases. These figures may be deceptive, however, as the sale totals include lots which were "bought in" by the auctioneers as not having reached their reserve price. As the number

of collectors is continually increasing and since the finest works are prohibitive in price and in public collections anyhow, it is clear that the rise in the value of prints is largely bought about to satisfy the demands of those unable to aquire paintings or water-colour drawings.

On the other hand, even the modest collector must be prepared to realize that print prices can rise and fall just like any commodity. There is no exact scale of measurement and it takes a lifetime of experience to hazard a likely estimate of the price a particular lot will fetch at auction. For example if the sale-room has been recently flooded with prints by a particular artist even a fine impression may realize less than it would have done six months earlier.

All of this means that the beginner will do well to confine his experience initially to watching, to sizing up the "feel" of the sales-room. He will get to know the various dealers and observe with initial astonishment, the unobtrusive and unemotional way in which they make their bids—from the back of the room, by an imperceptible movement of the head or by raising their sale catalogue gently. The professional dealer or bidder will fix a "ceiling" for a particular print and not exceed it, however great the temptation.

No matter how high the reputation of the sale-room it is most important to inspect a prospective purchase, even though the best firms of auctioneers will not accept a print for sale unless they reasonably believe it to be genuine. If you are unable to view yourself it should be done on your behalf by a specialist dealer; it will have to be "on commission" because after all you are trusting to professional expertise gained from a lifetime's experience.

Under the new Misrepresentation Act, fine art auctioneers now include in their catalogues an explanatory notice. In the case of firms like Sotheby's and Christie's, this is all that's required, but smaller provincial sale-rooms without the necessary specialist expertise sometimes include prints for which exaggerated claims are made. The large firms employ highly skilled specialist staff whose job it is to take immense pains to verify the authenticity of a particular item before

entering it in the catalogue. Even so, Sotheby's sale catalogue contains a warning notice, as we saw in Chapter 3, while a paragraph of their "Standard Conditions of Sale" reads:

"All lots are sold as shown, with all faults imperfections and errors of description. Neither Sotheby & Co., nor the vendor(s) are responsible for errors of description or for genuineness or authenticity of any lot, or for any fault or defect in it. No warranty whatever is given by Sotheby & Co. or any vendor to any buyer in respect of any lot."

A catalogue may have a code name, e.g. "Alpine", "Primrose", "Dolittle", to be used by customers when sending commissions, especially from overseas. The price of a catalogue depends on the quality of the sale and number of illustrations. Subscription terms may be advisable for the collector who really wants to get to the bottom of his subject. Generally speaking, for an average sale, the catalogue price would not exceed 3/– (1970). After the sale is over, a printed list of all prices registered, together with buyers, can be supplied at a rate of 3/– for each day of sale.

If a collector feels that he just must have a particular print and, despite all the advice that has been proffered, decides to go ahead and purchase unseen, then the auctioneers will execute bids and advise intending purchasers for nothing. Lots will be bought as cheaply as possible, subject to other bids and the reserve price agreed with the vendor who will have to pay 15% of the proceeds of the sale to the auctioneers. To some extent it will be seen from this that the auctioneer has encroached on the functions of the dealer.

If this sounds complicated, it works out quite well in practice and the print collector may consider himself fortunate not to buy at Paris art auctions. It is nothing nowadays for the bigger dealers and auction sales-room directors to travel between the world's art centres. Sotheby's now have branches in Italy and Canada and there is a Christie's office in Geneva.

The archaic status of French auctioneers arises out of the Napo-

leonic Code which sought to protect both buyer and seller from dishonest practices. A French auctioneer is an official nominated by the Ministry of Justice who is not allowed to purchase on his own account.

Working closely with him will be the Fine Art "Expert", also an official who is able to give a professional opinion on a particular item. This explains why the letters "Expertises", or the words "Expert Accredité", can be seen in some printsellers' windows in France.

The prospective buyer in France might also note that a 16% tax is levied on all sales under 6,000 francs, falling to 10% on a sliding scale as the item sold increases in value. This all goes to explain why Sotheby's and Christie's in London and Park Bernet in New York see more prints coming through their hands than the Palais Galliera in Paris or the Salle Provana in Nice.

In passing, it may be worth noting that occasionally a worthwhile print is to be found even nowadays on the French or Italian Rivierias. Wealthy English families lived here in style up to the outbreak of the First World War and not all their treasures have disappeared. Recently a fine, leather-bound copy of Smollett's *Roderick Random* was on offer in a small Nice bookshop for the equivalent of £2 10s. The print-collector would be delighted to acquire so charming a trifle if only for the two fresh stipple engravings it contains by Sunderland-born Thomas Ranson, after Richard Corbould who was a particularly successful book illustrator.

The print-collector may, however, be only too willing to resort to the sales-room here or in France, but, again, he may be frightened because of what he has read of Auction Room Price Rings. This is an illegal buying system by which dealers agree not to bid against each other so that the true value of an article is not realized. A dealer will act as "a man of straw" tendering an opening bid of, say, £25 for an item worth £750 (or more), while his colleagues in the room, all of them knowing its real value, stay silent. After the auction, a complicated "knock out" sale among the dealers in a nearby pub enables them all to pocket tax-free cash.

Antique furniture and books used to be the media in which the "rings" operated mostly and it may well be that this is still the case with books, but prints have tended to fall outside the interest of the ring, very likely because the type of general dealer comprising its membership does not himself possess the necessary degree of specialist knowledge to assess them accurately.

Reputable printsellers and antique dealers obviously deplore such practices and Sir Alec Martin, formerly of Christie's, puts his finger on both diagnosis and cure: "If you have antiques to sell, go to an expert and have them properly valued. Human nature is often wicked and people are always out to get things as cheaply as they can, but where you get goods properly catalogued, the catalogues fully circulated, and a cross-current of bidding in the sales-room, private and trade, no great harm can be done even if some dealers have banded together."

At both Sotheby & Co., 34 & 35 New Bond Street, London W.1, and Christie, Manson, Woods & Co., 8 King Street, St. James, London S.W.1, the print sales are of the highest calibre. This is not to say that there will not be the occasional bargain which the dealers do not want for some reason. It may be a bad sign if the dealers have nothing to do with a print, as they have possibly realized that it isn't all it sets out to be. Equally conceivably it may be one that none of them want at that particular moment or that experience suggests is likely to stay on their hands some time.

Other print sales-rooms include Phillips, Son & Neale, Blenstock House, Blenheim Street, London W.1; Bonhams, Montpellier Place, London S.W.7; Morrison, McChlery & Co., 98 Sauchiehall Street, Glasgow C.2 and Henry Spencer, 20 Market Place, Retford, Notts.

Details of sales are published each Monday during the season (September to July) in the *Daily Telegraph*, each Tuesday in *The Times*, and each Sunday fortnight in the *Sunday Times*. Particulars are also available in the specialist art press which includes the monthlies— *Apollo, Burlington Magazine, Connoisseur, The Antique Dealer* and *Collectors Guide* and the bi-monthly *Antique Collector*. There is also an

Art and Antiques Weekly. In the case of these magazines, there will be photographs of the choicer items offered for sale. It is also worth while to glance at the list of contents for the occasional feature article useful to the print-collector. Best of all for the sales-room enthusiast is the subscription taken out for sales-room catalogues and, in case this seems expensive, they prove invaluable for reference in future years and usually find a ready buyer when no longer required. Where a collector needs to consult an old sale catalogue, the Library of the Victoria and Albert Museum is usually able to provide a copy for reference.

OTHER METHODS OF BUYING AND SELLING PRINTS

The dealer and the sales-room are obviously the main sources for the acquisition of prints and are probably the safest, in that order.

Regarding newspaper advertisements, including the quality "Sunday's", watch out for the *caveat* "No dealers", which may, but certainly not necessarily, suggest that the print for sale has already been offered to a dealer who has recognized in it some defect.

One new way for the collector to keep in touch with price trends, and for that matter with fellow collectors, is to join the Antique Collectors' Club, based at The Old Rectory, Clopton, Woodbridge, Suffolk. Buyers and sellers are put in touch with one another and avoid the middleman or dealer, so that no question of a "ring" applies. Of course, this club deals with the whole range of antiques, but specialist hobbies like print-collecting obviously form one of its multifarious activities.

More specifically, the Royal Society of Painter-Etchers holds exhibitions in its rooms at 26 Conduit Street, London W.1, which premises Sotheby's also use occasionally for sales. The opportunity exists on such occasions for the modest print collector to add to his collection the work of a living artist.

I'm not much in favour of street-corner purchases of prints on a fine Saturday afternoon, and am also chary of some of the antique

"fayres" held up and down the countryside. The village jumble sale is also a pretty improbable venue, although it might turn up a chromo-lithograph from somebody's great-grandmother's attic.

The print-collector in the excitement of building up his collection is apt to forget that one day he may wish to sell all or part of it. If he should sell he'll realize the difference between buying and selling and might be glad he confined his collection to well-chosen examples. Most reputable dealers will be pleased to buy back good-quality prints from regular and, even, other customers. The continual depreciation in the value of money will probably ensure that the collector suffers no financial loss, provided he has kept his print for at least five, or, better, ten years. It also pays to be in no hurry to sell. A club like the Antique Collectors' Club will provide a ready market place and free of the auctioneer's percentage—usually 15%. An insertion in the Fine Art Press may also prove rewarding for a really fine impression. The advantage of the big London sales-room is obvious. Connoisseurs and dealers alike respect its proven status and despite the auctioneers' commission the print may well realize more there than elsewhere. Provincial sales-rooms still do not always understand prints and may not have staff with the necessary expertise in cataloguing. For all but the cheapest and poorest impressions, they are to be avoided by would-be sellers.

Frauds and Forgeries

A *forged* print is a print made with intent to deceive. A *reprint* is a print taken from an original plate at a later date to meet a demand from collectors.

A law that applies to print-collecting just as much as to other forms of activity within the fine arts, is that of supply and demand. If collectors want Picasso lithographs then, sure enough, Picasso litho-graphs will turn up for them. At the turn of the century, when stipple subjects by Bartolozzi and his followers were in vogue, forged Bartolozzis appeared on the market as plentiful as swallows in

summer. Certain categories of print are always sought after, like sporting and coaching prints, so that particular care is needed when considering a purchase that may be costly.

To the experienced eye, the authentic print shrieks "quality" from the housetops, but non-experts must study prints carefully and frequently, in public and other collections. Reference has already been made to the smooth surface that comes from photographic work. This underlines the necessity, if one is not buying from a reputable dealer, of scrutinizing a print in strong daylight. This means taking it out from under any glass, and not many dealers, especially of the "street-market" variety, may be prepared for prospective clients to do this. If the surface is unnaturally rough, it may have been cleaned with acid, in which case some of the lines on the print may be broken. The unscrupulous have been known to "iron" a print so treated with a hot iron. This brings about an unnaturally glossy surface in place of the roughness. The absence of a plate mark may also suggest a photographic forgery.

A print I'm glad to have in my possession but which is not all it seems to be is *Love*, a delightful coloured stipple engraving by Thomas Ryder after Richard Cosway. Unfortunately, close scrutiny reveals a suspiciously smooth surface, while under a magnifying glass all the "dots" show up uniformly, when, as in an original, the "reds" and the "blues" should stand out in relief from the white background. Probably a photographic impression of the 1920s, it was bought in the Portobello Road Street Market for ten shillings. What can one expect at this price? The anecdote is a good illustration of the old Latin tag, *caveat emptor*—"let the buyer beware". It is still both good law and good collecting sense even with the Misrepresentations Act on the statute book.

Sometimes the genuineness of a print can be decided by its dimensions. Most of the works of reference, like Bartsch, give the size of a print, so that one which is much smaller or larger than it ought to be is, *prima facie*, suspicious. If the forger has provided a "plate mark" it will be larger or smaller than it should be.

It has been known for a collector to have been offered a "counter-proof". This means that the print was taken not from a plate but from a finished impression. Such counter-proofs will have the design reversed and are usually faintish impressions. A collector may also be offered a "false proof". In this case, an impression taken from a fully lettered plate, that is with letters below the design, is pulled with a piece of paper over the lettering, "stopping out" the inscription. Such an impression without lettering, if genuine, is more valuable because it's earlier, hence the reason for the forger's pains. A "false proof" can be detected by the indentation left by the paper used for "stopping out" on the margin below the impression.

In the case of Old Master prints, the size of the margin may be crucial to prove authenticity. Really early prints have very little margin, so there is something wrong if one is offered a Dürer engraving with a wide margin. Conversely, wide margins are customary from the eighteenth century onwards, so that a print of Wheatley's *Cries of London* will be less valuable with its margin cut close or trimmed to the plate mark for framing purposes than if it had full margins. One needs to be realistic, though. The collector is paying for the impression and not a stretch of blank paper, so that the importance of margins should not be over-rated.

Paper and watermarks can provide a safeguard for the collector as it isn't worth the forger's while to print on old paper unless the print concerned is desirable and rare. Unfortunately, the study of watermarks and paper generally is pretty specialized so that the ardent collector has little choice other than to consult one of the appropriate works of reference. The classic work is still the mid-Victorian *Paper and Paper-Making* by R. Herring, published in London in 1855. As time goes by, the collector acquires a feel for good-quality paper. Most of the paper used after around 1800 was machine made and is more uniformly thick and smoother than older paper. Hand-made paper possesses an altogether coarser texture. If a print feels unusually thick it may have been fixed to another sheet of paper of similar size and texture, possibly to hide some defect. One thing the wise collector can

do is to note genuine watermarks as he comes across them and enter them up in his own private notebook for future reference.

Prints can sometimes be found which bear the name of a former owner. It may be that he was or is well known as a collector of taste, so that such a mark is evidence of the integrity of a print, like a hall mark on silver. Collector's marks can be forged but, often, this type of print has a well-documented pedigree, coming from a descendant of the collector so that the "provenance" is known to be good. Some well-known collectors included Edward Astley, John Barnard, John Chalon, William Cole, Richard Ford and G. W. Reynolds.

As evidence of ownership, some prints bear the collector's initials, e.g. B.W. for Benjamin West, D surmounted by a coronet for the Duke of Devonshire, J.B. for John Barnard. Some famous collections used more special marks. King Charles I's prints bore an eight-pointed star, Sir Joshua Reynolds had "Sir I. R." within a square, the collector Thane wrote his name backwards and the eighteenth-century portrait painter Nathanuel Hone used the human eye as his device.

It is unlikely that most collectors will come across this type of mark on prints except in public collections, so that these marks are by way of being a picturesque curiosity. The collector will, of course, evolve his own system of listing his property.

Unhappily, wily as the forger may be, an even harder bird to track down is the perpetrator of reprints. These may have been produced without the slightest intention to deceive, but the fact remains, and this is especially the case with modern reprints, that they can hardly qualify for consideration in the same way as those first impressions we call originals. The reputable dealer will invariably indicate if an impression is from a later edition, or from cancelled plates. A lot of bother would have been saved to posterity if printsellers and publishers had destroyed their plates after printing!

It cannot be stressed too often that a desirable print is an early, good-quality impression "pulled" from the original plate by the artist himself or, at least, under his supervision. This is because it is inevitable that a plate will get worn with use; the lines on it will

get broken so that the impression produced at a later stage will miss all the sharp, decisive clarity of the first impressions. This can easily be established by comparing very early and late impressions from the same plate.

The result is that the plate has to be retouched, "vamped", "improved", in order that any kind of acceptable impression is possible. This may have been done long after the original artist's death. Sometimes this touching up process results in a black tone as unnatural as a woman with badly-dyed hair. Its very unexpectedness arouses suspicion.

It is also worth repeating that the prints which are reprinted or forged are the ones that people often want, the early Old Masters like Rembrandt or Dürer, and, above all, the popular colour prints. These are categories of print to approach with special care. The reader will recall that a colour print is one which has actually been printed in colour and that many of the topographical prints he will be offered are engravings coloured by hand, sometimes by children.

In another context, children provide some explanation as to why relatively few engravings exist in really fine condition. The printsellers were great popularizers and many prints involving social comment were regarded as such by the populace. They were not appreciated at their real worth and certainly no one foresaw the present age of high prices. Children amused themselves by pasting them in scrap books, some were cut to fit screens, frames or fans, or stretched on frames and varnished.

LOOKING AFTER PRINTS

Many people who buy prints nowadays do so to hang them on the walls of their home. This is quite at variance with the ideas of the old-time collector who will have kept them in a portfolio or box. Prints to be framed are best left to the professional, especially if they are fine examples of their type. Convention of no great importance suggests that good topographical specimens may best be framed in

black and gilt "Hogarth" frames; Gillray etchings can be attractive with narrow, gilt frames and nineteenth-century flower prints look pleasing in bird's eye maple wood. The rich black engravings of Edward Calvert and Samuel Palmer are perhaps most appropriately framed with thin black frames, while white wood can be used for twentieth-century artists. Technically it is the mount and not the print which is framed and if the back of the frame is hinged the print can be removed when needed.

Colour prints, especially when fresh and vivid, need protection from even the English sun. There are several public collections which bring such prints out only in mid-winter or where the print hangs behind a moveable curtain.

One of the most useful addresses in London as regards framing and the care of prints generally is: James Bourlet & Son, 17 Nassau Street, London W.1.

Sometimes, but not often we hope, the collector will acquire a print with fox marks or stains caused by dirt, damp or a fungus. Perhaps an impression may be damaged by tears or holes, especially if it is old. It is possible for the collector to carry out a certain amount of self-help but both care and skill are required. It is usually better to confide the damaged print to an expert restorer on the principle of not "spoiling the ship for a ha'porth of tar".

For the persistent "do-it-yourself" collector, and provided the print is not very valuable, the following bleaching solution is reasonably safe and will remove most fox marks and similar stains: dissolve one ounce of chloride of lime in one gallon of distilled water. Next, dissolve in a separate container four fluid ounces of hydrochloric acid (not commercial grade) in one gallon of water. Dip the print alternately in the two solutions for fifteen minutes, starting with the lime chloride. As soon as the stains disappear, wash the print generously with water. Finally, lay the print on a piece of glass to dry as it will be fragile when saturated.

If the area to be treated is small, it can be dabbed with blotting-paper soaked with hydrogen peroxide and then washed thoroughly.

The back of the print can be dabbed just as effectively. Holes can be disguised by pasting a matching piece of print over them. The skilful operator, by rubbing the edges of the hole with his index finger, is apparently able to fray the surface and edge the patch and print surface together until they blend. This surgery has to be carried out on both sides of the print which is then brushed with a weak surface of cellulose acetate.

For Japanese prints, print folk lore has it that new bread may remove stains followed by a wash with distilled water. This may well be because the colours are not "fast".

All collectors, however skilled or clumsy with their hands as regards repairs, will need to store that part of their collection which is not hung. A solander box is probably best for this. It's a box of special design made of millboard which opens horizontally and which can stay open like the pages of a book. Most good bookbinding firms would probably undertake to make such boxes to order. Two London firms are: The Wigmore Bindery, Block B, 175 Bermondsey Street, London S.E.1., and Sangorski & Sutcliffe, 1 Poland Street, London W.1.

It may well be that the collector will need to devise his own specifications, but the measurements of the solander box should be sufficient to take the larger mounted prints, say 2ft. by 1ft. 6in. Examples of solander boxes can be seen in the print room of the British Museum.

These boxes are more effective than portfolios, which have to be tied together with tapes and which also require strong cloth flaps to keep out the dust.

Prints are best kept loosely mounted on good quality mounts; avoid cardboard, which has a tendency to warp. At the British Museum prints are sited below the level of the mount and this is probably a very satisfactory method.

Some collectors keep their prints in a large folio-sized book, attaching each print by a hinge to the paper leaves. The old collectors favoured muslin for this purpose. If only one corner of the print is

attached, it can be lifted up and scrutinized, including also the back.

A collector will also be wise to list all his acquisitions in a separate volume. A full description including title, painter, engraver, date, publisher, the date acquired and price paid are minimum particulars. This can be a satisfying volume to show to admiring friends as the years go by.

Further Reading

Reference Works

Dictionaire des Peintres, Sculpteurs, Dessinateurs et Graveurs, by E. Benézit, 8 volumes (Librairie Gründ, Paris). (There is no English translation of this work, which is much more informative than the out-of-date Bryan, below).

Dictionary of Painters and Engravers, by Michael Bryan, new edition, 5 volumes (George Bell & Sons, 1904–5). (A two volume edition of 1888–9 is in some ways more satisfactory, especially as it includes details of lesser known English engravers which are omitted in most recent editions.)

Dictionary of Artists of the English School, by Samuel Redgrave (G. Bell, 1878). (Unfortunately, this is small and long out of print. It contains a mass of detail about minor artists.)

Engravings and their Value, by J. Herbert Slater—6th edition, edited by F. W. Maxwell-Barbour (The Bazaar, Exchange & Mart Ltd., 1929). (This large, impressive work is out of print and found only with difficulty. It is a splendid book and in its own words provides "a complete guide to the collection and prices of all classes of print".)

General Works on Print Collecting

Chats on Old Prints, by Arthur Hayden (T. Fisher Unwin, 1906). (This delightful volume is written in the friendliest yet most knowledgeable way. It is over sixty years old but a modern edition was brought out by C. G. Bunt in 1956 for Messrs. Ernest Benn.)

A History of Engraving and Etching, by Arthur M. Hind,—1908. (This volume by a former Keeper of Prints at the British Museum was reprinted in 1963 by Dover Publications Inc. of New York and distributed in this country by Constable & Co. It is a work of great scholarship with complete bibliography and classified lists of engravers.)

Fine Prints, by Frederick Wedmore (John Grant, Edinburgh, 1905.)

The Print Collectors Handbook, by Alfred Whitman. (6th edition by Malcolm C. Salaman 1912.). (The above two volumes are typical of the works published in the early part of this century during a similar period of peak interest in prints.)

Six Centuries of Fine Prints, 1937, by Carl Zigrosser—New York.

The Book of Fine Prints, 1948, by Carl Zigrosser—New York. (Two impressive American contributions, they are more readable than most scholarly works of their type.)

Great Prints and Printmakers, by Herman J. Wechsler (Thames & Hudson, 1967). (A recent and comprehensive volume of 'coffee-table' dimensions.)

The English Print, by Basil Gray, (A. & C. Black, 1937). (An impressive if austere volume as might by expected from a man who worked long years in the Print Room of the British Museum.)

How to Identify Old Prints, by F. L. Wilder (Bell, 1969). (A scholarly volume from the print expert of Sotheby.)

The Care and Conservation of Prints

A Guide to the Collecting and Care of Original Prints, by C. Zigrosser and C. M. Gaehde (Arco, 1966).

Special Categories (books published since 1960.)

A. M. Hind's volume referred to above contains full details of the classic works.

Old Masters

The Appreciation of Old Engravings and Etchings, by E. F. Linssen (H. Jenkins, 1951).

The Eighteenth century

Graphic Art of the 18th Century, by Jean Adhémar (Thames & Hudson, 1964).

The Nineteenth Century

Graphic Art of the 19th Century, by Claude Roger-Marx (Thames & Hudson 1962).

Victorian Book Design and Colour Printing, by Ruari McLean (Faber & Faber, 1963). (This book revolutionized the collector's attitude to the subject.)

Modern Prints

About Prints, by S. W. Hayter (Oxford University Press, 1962); *New Gravure*, by S. W. Hayter (Oxford University Press, 1966).

Lithography
 A History of Lithography, by W. Weber (Thames & Hudson, 1966).

Wood Engraving
 A History of Wood Engraving, by D. P. Bliss (Spring Books, 1964).

Caricature
 Mr. Gillray, the Caricaturist, by Draper Hill (Phaidon Press, 1965).
 Fashionable Contrasts, Caricatures by James Gillray, by Draper Hill, introduced and annotated by Draper Hill, (Phaidon Press, London 1960).
 Hogarth: the Complete Engravings, by Joseph Burke and Colin Caldwell (Thames & Hudson 1968).
 Hogarth to Cruikshank, Social Change in Graphic Satire, by M. Dorothy George (Allen Lane, The Penguin Press, 1968).
 The Bite of the Print—Satire and Irony, by Frank & Doris Getlein (Herbert Jenkins, 1964).

Japanese Prints
 The Japanese Print, by J. R. Hillier (George Bell, 1960).
 The Graphic Art of Japan—the Classical School, by O. E. Holloway (Tiranti, 1967).
 Harunobi and his Age, by D. B. Waterhouse (British Museum, 1964).

Glossary

Ad vivum: (*from the Life—Latin*). Sometimes found to follow the engraver's name in the case of a portrait. It indicates that the work has been done from life and not from a painting.

After: When describing a print, one may say that it is "after" a particular painter. This means that the print is not the engravers' own original composition but that he produced it from another man's design. Thus, "Dancing Dogs" by Thomas Gaugain after George Morland means that Gaugain engraved "Dancing Dogs" by looking at Morland's painting of the same name. The fact that, for some, the aesthetic level of his print may be higher than the original oil is neither here nor there.

Aquatint: A means of engraving by the use of acid on a resin "ground".

Artists Proofs: The earliest impressions taken from a plate which are satisfactory to both artist and engraver. They may be signed by both artist and engraver in the bottom margin, or possibly by the artist only. In this latter case, a proof known as the *Engraver's Proof* may bear the engraver's signature; although this may also indicate working proofs pulled from time to time by the engraver to check on the progress of his printing.

Backed: Not a horse-racing term but refers to a print which is lined with paper of a similar composition and quality.

Biting: This is the action of the acid upon metal when drawing on the plate.

Burin: This is the hard steel tool with a cutting edge used by the engraver. An alternative name is the *graver*.

Burr: The ridge left by an engraving tool in engraving a metal plate. Its existence is highly important for the production of rich, velvety mezzotint tones.

Chiaroscuro: A means of engraving by superimposing different blocks so as to produce effects of light and shade.

Counter-Proof: An impression taken from a proof impression and not from a plate. The design is thus the wrong way round.

Cross-Hatching: Lines cutting across each other to improve the general effect.

D., Del., Delin., Delt., Delineavit: ("*He drew it*"). When this follows the artist's name, it means that the print is after a drawing and not an oil painting. A

water-colour is technically a drawing in addition to a design in pencil, chalk or crayon.

Dry-Point: When the etching-needle is used on bare copper-plate. Etchings are sometimes finished by dry-point.

Etching: A means of engraving on metal with a needle with the help of acid acting on the surface.

Execudit or *Fecit*: ("*He did it*"). Can be used instead of *Pinxit*.

False Proof: An impression taken from a plate with letters below the impression but with the lettering deliberately omitted.

Fond Sale: A French expression ("dirty bottom", literally). It refers to an inky smear which is brought about when an unsatisfactorily polished copper plate is used by an engraver.

Foxing: Spots or stains on a print usually brought about by fungus or damp.

Graphic Art: The name given, generally, to the art form produced by printing methods.

Graver: see *Burin*.

Ground: The specially prepared surface of a metal plate or wooden block on which the design is to be worked.

Laying Down or *Laid Down*: A print is laid down when it is pasted on paper, cardboard or similar substance.

Lettered Proofs: These are the impressions printed immediately after the Proofs before Letters. The letters include the title, the names of the painter and engraver plus that of the publisher.

Line Engraving: Lines engraved on a metal plate or wooden block so as to create a design.

Lithograph: A print taken from a special stone upon which a design has been made with a greasy pencil or ink.

Mezzotint: A tonal process of engraving on a copper or steel plate whereby dark and lighter shades are produced by means of scraping and burnishing the metal.

Parcel: A sales-room term for a mixed lot of prints, usually not of sufficient value to be sold separately.

Pinxit: ("*He painted it*"). Follows the painter's name on the print.

Portfolio: Either specially-made leather or millboard covers which tie up with tape to hold prints; or whole collection of prints—the collector's portfolio.

Proof: In its original meaning this is an impression taken from a plate for the purpose of scrutiny by the engraver with a view to alterations or correction.

It can also refer to an impression from a fully satisfactory plate prior to the issue of the normal fully lettered prints.

Proof before Letters: A fully satisfactory impression which bears no inscription. The title is not printed. The names of the artist and of the engraver may be printed below.

Reprint: A late impression taken from an original plate.

School: The followers or pupils of a particular artist, or it can also refer to a particular place, e.g. the Birmingham School of Engravers or the Norwich School of Landscape artists.

Scraper: An engravers' tool used in mezzotint to scrape away the metal.

Sculpsit: ("*He engraved it*"). Follows the name of the engraver on a print.

Soft-Ground Etching: A technique to imitate the texture of pencil drawings.

Solander Box: A specially designed box of millboard or similar material which opens horizontally and stays open like the pages of a book. It is used to store prints.

State: Relates to the condition of a print in its various stages. Impressions taken from a plate may be "First", "Second", "Third" and so on states, or "only" state according to the number of alterations and additions the engraver may make.

Stipple Engraving: A style of engraving whereby the design is pricked out with tiny dots instead of lines.

Stopping Out: A method of covering part of the metal plate used in etching with wax or some other acid-resistant substance.

Index